CLAES OLDENBURG COOSJE VAN BRUGGEN

MAY 3 – JUNE 28, 2002 **PACEWILDENSTEIN** 534 WEST 25TH ST. NY NY 10001

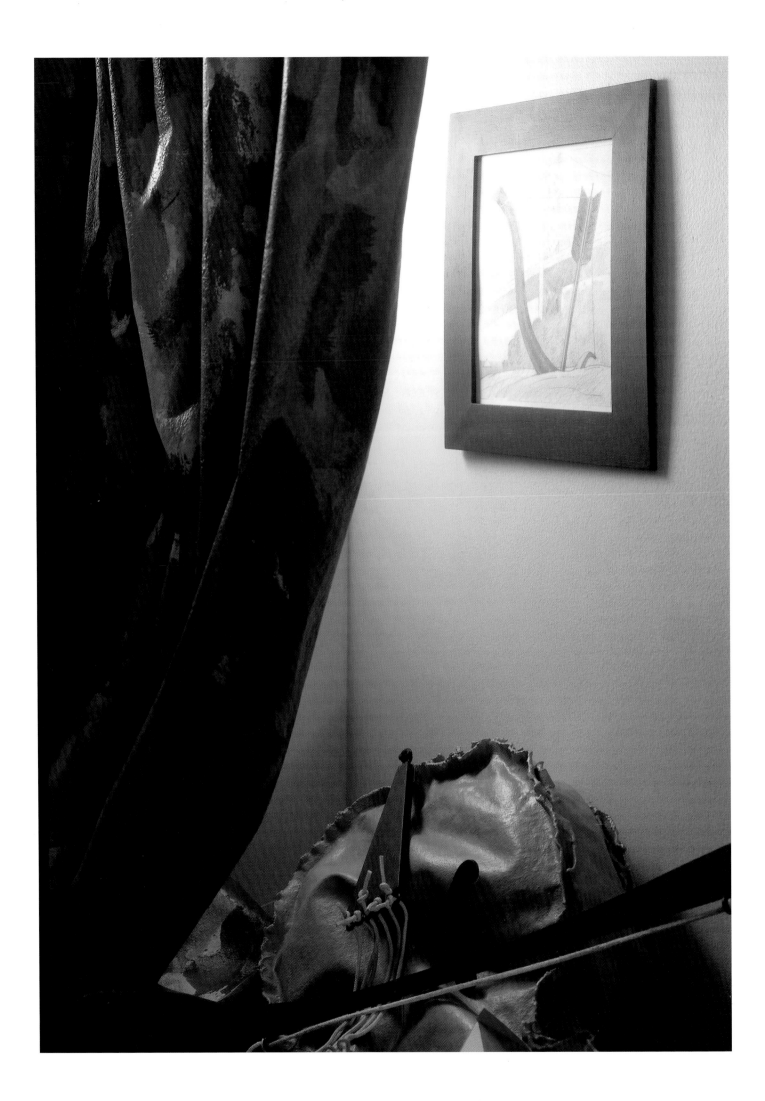

IF MUSIC BE THE FOOD OF LOVE, PLAY ON...

New Sculpture by Claes Oldenburg and Coosje van Bruggen

INTRODUCTION

The first and last works in this exhibition transport us in imagination to the seventeenth and the nineteenth centuries, even as they also convey freshness and urgency of experience in the twenty-first, in which they were made. Moving from one to the other of these sculptures, the viewer progresses not only through time but also from private to public, from indoors to out, and from the intimate to the monumental.

The exhibition's central theme is the pull exerted by the senses. By subjecting motifs to processes of deconstruction, concentration, and fabrication, and by choices of texture and color, the artists not only evoke all five senses strongly, but also heighten our awareness of them. The works' focus on deceptively familiar objects also prompts reflection on desire and its pursuit. The artists interrelate the elements of each work so as to identify a key moment of change, a moment of liberation from the constraints of the known or the preordained. By adjusting the scale of some objects and by introducing elements of disruption, they open their motifs to greater complexity of reference and meaning. They uncover the link between object, emotion, and memory.

Oldenburg and van Bruggen are American citizens who divide their time between the United States and France. The works in this exhibition were made in both countries and draw upon the culture of each, as well as reflecting aspects of the cultures of the artists' countries of origin (respectively, Sweden and the Netherlands). Their art, created jointly for a quarter of a century, is also a fusion of their individual personalities. More often than not, a work comes into existence when an idea conceived by van Bruggen as an image is recorded by Oldenburg in a notebook sketch. From this starting point, concept and image develop in tandem, through stages propelled by a dialogue to which the artists contribute equally. Each introduces surprises into the trans-

action, and as the work evolves it becomes impossible to define them simply as conceiver (van Bruggen) and maker (Oldenburg), for their roles interchange unpredictably. The two artists' inputs become so integrated that in many finished works it is almost as if, whatever a sculpture may depict, an important part of its subject is their partnership.

CONSUMMATION AND MEMORY

Coosje van Bruggen, who was trained as an art historian at the University of Groningen, has long had a special interest in seventeenth-century Dutch painting. Of particular interest to her is the work of Johannes Vermeer, whose peopled interiors communicate a sense that more is going on than we are shown. For van Bruggen these interiors are alive with an intensity of relationships, not only between forms in three-dimensional space, but also between the figures whose observed activities seem at first so matter of fact, as well as between them and the unseen figures whose imminent involvement is implied. Matters are further complicated by the immediacy with which Vermeer invests each inanimate object. The presence of objects is so compelling as to give them as active a role as that of humans, for whom they can sometimes be read as surrogates. Finally, the viewer is not only made unusually aware of perspective, but almost mesmerized by its effects. Thus for all its supreme harmony and balance, an interior by Vermeer contains elements that variously disrupt those very qualities. At the heart of Vermeer's importance for Oldenburg and van Bruggen is his use of still life to open vistas of a life that is anything but still.

Crucial in *Resonances, after J. V.*, (2000; p.19), as the title might imply, is the role of stringed instruments, one of the recurrent motifs of Vermeer's art. The sculpture was inspired by two Vermeers in particular, *A Young Woman Standing at a Virginal* (Fig. 1), and *A Young Woman Seated at a Virginal* (Fig. 2),

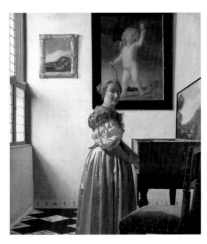

Fig. 1:
Johannes Vermeer
A Young Woman Standing at a Virginal, c. 1670
Oil on canvas, 20 3/8 x 17 3/4"
The National Gallery, London

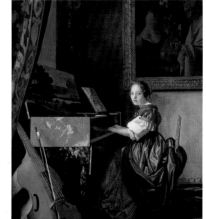

Fig. 2
Johannes Vermeer
A Young Woman Seated at a Virginal, c. 1670
Oil on canvas, 20 1/4 x 17 7/8"
The National Gallery, London

both in the National Gallery, London.[1] Van Bruggen sees these pictures as "stills" that freeze moments in a continuous narrative, the subject of which is love. In each painting the woman is alone, but the vital part played by men in other Vermeers, including scenes of music-making,[2] is far from being the only pointer to their importance in the story these paired pictures tell.

For van Bruggen, the woman standing is anticipating the arrival of her lover, whom an empty chair awaits. In this painting, the largest of several pictures within a picture is an image of Cupid, whose bow actually touches the woman's head, pictorially. By contrast with the relatively austere and measured design of this Vermeer, the picture of the seated woman is more complex and crowded. Metaphorically, the woman's lover has now arrived. Whereas it is unclear whether the standing woman is actually playing the keys that she fingers, her seated counterpart is "playing" in more senses than one. As if to confirm the theme of lovemaking, the largest of the paintings depicted here shows a scene with a procuress. *Resonances, after J. V.* was prompted by van Bruggen's regret that no third Vermeer exists to reveal what happens next. That, therefore, is what she and Oldenburg show us in their intricate tableau.

Attention has already been drawn to the importance in Vermeer's paintings of roles, of enclosed spaces, and of figures entering into them. To these factors may be added the crucial element of lighting. It is thus apt that Oldenburg and van Bruggen should present the third moment in this narrative in the form of a small stage. Following a genre in the Dutch art of Vermeer's day, they have created a peep show, which may be compared with an example by Vermeer's contemporary Samuel van Hoogstraten, *A Peepshow with Views of the Interior of a Dutch House* (Fig. 3). This likewise gives prominence to chairs and to a patterned floor. Its outer surface depicts Cupid. However, Hoogstraten's peep show and that by Oldenburg and van Bruggen show different stages of Cupid's activity, which helps explain the contrast between the orderly character of Hoogstraten's interiors (and the first of Vermeer's) and the disarray that prevails in *Resonances, after J. V.*

In this difference strings play a vital role. In Vermeer's painting of a young woman standing, Cupid's strung bow is at the ready. By the time of the second picture the artists visualize his arrow as having been shot. Thus when in the third "still" (their own) Cupid's bow reappears, it has been hung up on the wall, its work done. The arrow that hangs beside it is bent, from the force of its impact on the lovers. The extent of that force can be judged by examining the stringed instrument that dominates the shallow space and even protrudes from it into our own, as if hanging over the edge of a bed. No longer leaning at the ready (as in the Vermeer painting of the woman seated), the viola da gamba now sags limply, as indeed does Cupid's arrow, which has become soft. The gamba's formerly taut strings trail slackly along its extended and deconstructed form.

The analogy between the form of any instrument of the violin family and a woman's body has long been celebrated in art. It is inevitably of interest to Oldenburg and van Bruggen, whose objects repeatedly refer to the shape of the human body, regarded as a key "given" of our existence. Though not there literally, a human presence can, paradoxically, be intensified when represented by objects. Moreover, to Oldenburg and van Bruggen the object is a receptacle for the projection of feelings. Here, therefore, the woman/gamba lies in a state of satiation. The lovemaking is over and we witness the confusion in which its ardor has left the room. The curious chair that intrudes into the scene extends the ambiguities of presence/absence and of metaphor that van Bruggen finds in Vermeer's paintings. Complementing the gamba's curves and pointing toward the reclining instrument, its sharply assertive form makes it a male presence by proxy. Its design repeats that of a famous Dutch object of the modern era, Rietveld's Zigzag Chair of 1934.

In introducing this anachronistic motif into a seventeenth-century scene, Oldenburg and van Bruggen reinforce their work's theme of disruption. They also augment the pervasive quality of instability. A supposedly firm object is collapsing; the black voids in its casing prove on inspection to be solids; and the tableau rests on a floor composed of angular lozenges, of which the black-and-white contrasts are visually

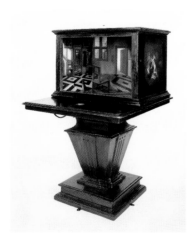

Fig. 3:
Samuel van Hoogstraten
A Peepshow with Views of the Interior of a Dutch House, c. 1655–60
Oil and egg tempera on wood, exterior measurements 22 7/8 x 34 5/8 x 23 3/4"
The National Gallery, London

unsettling. The sense of disorientation is compounded because Cupid's arrow, both types of bow, the chair, the envelope, and the floor patterning all point in different directions. The atmosphere is one of mysterious concealment and revelation, in which the heavy curtain (another stagelike feature) plays a major role.

An earlier work that fed into the conception of *Resonances, after J. V.* was Oldenburg's famous *Bedroom Ensemble* (Fig. 4), the first version of which was made in 1963. That work is likewise stagelike, includes furniture and pictures on the wall, and confuses perception by tricks of perspective. It, too, juxtaposes soft with hard forms, though without according central importance, like so many of Oldenburg's works of that decade, to changing the very meaning of a customarily hard object by making it soft. In the new peep show, where this does happen, the collapsed viola da gamba has "given in," its helpless state resembling not only the end of life but also the "small death" with which orgasm is traditionally equated. The force of the emotion embodied in this object, as in the piece as a whole, is an indicator of a key contrast between the *Bedroom Ensemble* and the much later interior. A frozen quality pervades the *Bedroom Ensemble*, which not only recalls an actual motel room, but comments on the stiff stylization of the interiors presented in furniture advertisements by conforming to (and, in the absurdity of three dimensions, exposing) the rigidity of their formalized perspective illusion.

Ellen Johnson has written that "in the *Bedroom Ensemble* the dwelling of Eros becomes a chamber of death."[3] Though Eros is (by contrast) at work in *Resonances, after J. V.*, a kind of death occurs here, too, as we have seen. But it is a death in the midst of life, a life that resonates with emotion and across time. It also spills out to the viewer, thus again contrasting with the *Bedroom Ensemble*, about which Johnson added that "chaining it off from its surroundings is unnecessary; its remoteness is intrinsic." There is a link between the feeling of fuller engagement in *Resonances, after J. V.* and the artists' more mature perspective. Their work is now more layered, even more "baroque," than the emergent art of the 1960s. It not only reflects a longer experience, but

constitutes an assertion of the permanent value of a richer, more complex art, not least at a time when fashion decrees the preeminence of the young.

The smaller objects that rest on the viola da gamba in *Resonances, after J. V.* invite alternative readings, or questions. Displaced in the frenzy of love, an earring lies where it has fallen on the hastily set-aside instrument. This detail suggests that the woman has departed; but why, and in what mood? The riddle is compounded by the adjacent envelope. The eye-catching diamond of its red interior (the color of love) holds the whole complex composition together, while emphasizing that the envelope is empty. In several of Vermeer's paintings the writing or receiving of letters is significant. *The Love Letter* (Fig. 5) links such an incident to the playing of a stringed instrument. Like Vermeer, Oldenburg and van Bruggen leave us to guess the contents of the message the letter contains. Thus not only love but also mystery lie at the heart of their tableau.

The envelope conveys that not everything is public. Vermeer's depicted characters are not the only people whose private relationships are celebrated, for while reinforcing our awareness of the love they perceive as animating Vermeer's figures, Oldenburg and van Bruggen also attest to their own for each other—and *its* privacy. Like Vermeer's paintings, *Resonances, after J. V.* includes pictures within the "picture." Thirty-three of these are images in the manner of Delft tiles, painted by Oldenburg to an iconography provided by van Bruggen. Their meanings are personal and, though some are discussed below, not all are disclosed.

The other picture within this "picture" is the framed drawing that hangs on the rear wall, behind the curtain, and can be viewed only obliquely. As in Vermeer's picture of a woman standing, it includes a representation of Cupid's bow (and, here, his arrow). It is a visualization of a large-scale sculpture soon to be sited alongside San Francisco Bay (p. 20). Unlike the "real" weapon that hangs beside it, the bow in this image is fully taut, on the point of release. Yet, mysteriously, it also gives a sense that the arrow has hit home, for both bow and arrow are partially embedded in the earth

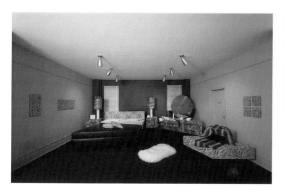

Fig. 4:
Claes Oldenburg
Bedroom Ensemble III, 1963–95
Wood, vinyl, metal, fake fur, muslin, Dacron, polyurethane foam, lacquer, 10 x 17 x 21'
Installed at the Solomon R. Guggenheim Museum, New York, 1995
Private collection

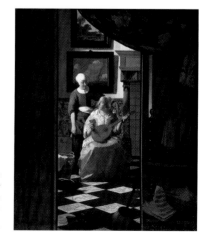

Fig. 5:
Johannes Vermeer
The Love Letter, c. 1669–70
Oil on canvas, 17 3/8 x 15"
Rijksmuseum Amsterdam

(and thus, in a further ambiguity, also read like the image of a ship plowing through waves).

Cupid's bow and the viola da gamba are both stringed contrivances. The new tableau may be soundless, but it resounds with recent melodies, as well as with memories of the love that Cupid's arrow has set in motion. Part of its subject is vibrations across time. Some of these reach us from Vermeer's world, which seems at once near and impossibly far, and some are from the artists' own memories.[4] But *Resonances, after J. V.*—conceived by a woman and executed by a man—testifies, too, to the equality of Oldenburg and van Bruggen's professional partnership in terms of the roles of each individual and each gender.

A FRENCH DOMAIN

The viola da gamba in *Resonances, after J. V.* is one of a family of transformed musical instruments by Oldenburg and van Bruggen that has been growing for a decade. A particular link between the artists and the music rooms their peep show recalls is their own creation of such a room at the home they established in Europe in 1992, in which they spend some months of each year. Much farther south than Oldenburg's native Sweden and van Bruggen's Netherlands, it lies in the Loire Valley, the favored region in which, significantly, the weather is generally held to change from northern to southern. The house, the Château de Laborde at Beaumont-sur-Dême, has strong American associations, for an earlier owner, Gustave de Beaumont, accompanied his friend Alexis de Tocqueville (1805–1859), after whom the street outside the gates is named, on the journey to the United States that resulted in the latter's renowned *Democracy in America*.

The music room at Beaumont-sur-Dême, formerly the salon, is an unusual example of the genre. Unplayable musical instruments, enlarged to the scale of human figures, hang on the wall or (in the case of a pair of clarinets elegantly arcing toward each other, their horns nearly touching) rest on the fire surround. One is another viola da gamba, its supposedly taut body yielding, owing to the softness of its materials. In his drawing studio, two floors above this room, Oldenburg recently visualized another gamba as an island, large enough for its hollows to become sheltering bays and its bridge a kind of Stonehenge (p. 24). But at Beaumont-sur-Dême transformation is everywhere. From the music room the eye is led to the park, which flows from the house in three directions and which contains not only natural growth but, in Oldenburg and van Bruggen's imagination, object-inhabitants that, like humans, take up positions among the trees (Fig. 6).

The artists' decision to live in the French countryside was born of their instinct to re-engage, in at least three different ways. They wished to extend the engagement with European culture that each had long pursued, despite having relinquished their original nationalities. They wished also to be able to operate more thoughtfully and at a slower pace than their working life on the East and West Coasts of America permits. Third, they sought to deepen the awareness of nature and of the elements implicit in their extensive practice of conceiving and installing large-scale site-specific sculptures around the world.[5] House, outbuildings, and park at Beaumont-sur-Dême are quintessentially French, the ensemble being complemented by the curved roof and spire on the belltower of the village church, visible just beyond the gates. However, as Oldenburg has observed, their estate is not so much in France as in Coosjeania. It was van Bruggen who took the lead in establishing this European base, and whose imagination and energy are steadily enriching both its arboricultural and its poetic scope.

Large numbers of trees were lost in the hurricane that hit the park at Beaumont-sur-Dême on December 26, 1999. This made possible not only replacement but reconstruction of planting projects on a grand scale. Blocks and drifts of contrasting color at ground level, and more especially above it, create views of great variety and animation. Trees and plants were sought from widely separated sources, so that the dialogue between large and small forms interweaves with that between different species and nationalities.

Fig. 6:
Claes Oldenburg and Coosje van Bruggen
from *Sketchbook: Sculpture for the Park (with J. V.)*, 1996
Pencil, colored pencil, watercolor, 6-3/8 x 4"

The longer they live at Beaumont-sur-Dême, the more the park heightens Oldenburg and van Bruggen's awareness of time (a preoccupation at the heart of their sculpture after Vermeer). As a living record of acts performed over the generations, the park *tells* the time in both decades and centuries, as well as in seasons. It also testifies to the endurance of the natural world in spite of wars and natural disasters. In this extensive landscape, to observe a particular effect of light, climate, or weather is frequently to recall a long-dead writer's account of precisely such an experience, often in the same month. This sense of a continuum has highlighted for van Bruggen the capacity of art to deal with time. The park's pervading peacefulness and the unforced rhythm of time there have the effect of slowing down the pressure and of permitting reflection, without which nourishing art cannot be created. Moreover, in a landscape that is both extensive and concentrated, the senses are heightened. As a consequence, the art of van Bruggen and Oldenburg is increasingly concerned with restorative delectation and with longer perspectives. In New York they are in the twenty-first century; in Beaumont-sur-Dême they feel just as much in the nineteenth.

Like art, however, the park is man-made. To cultivate it is to recognize how often what we perceive as natural is anything but nature in the raw. Life at Beaumont-sur-Dême also enhances the artists' awareness that their art springs from an interaction between the urban and the rural. Indeed, in the middle of a reverie amid Beaumont's glades, one can be startled by the scream of fighter jets. And it is not there but at a factory in American Canyon, California, that the artists oversee the physical realization of the outdoor sculptures they have conceived and visualized in France. The final choice of color for any work is entrusted, as is the artists' custom, to van Bruggen. It is the outcome of long deliberation aimed at heightening identity, radiance, and sensuous vitality. A living, organic quality is sought. Color is crucial in transforming the often strongly linear character of the drawings for a sculpture into a vivid three-dimensionality. At the same time, it has the effect of directing attention to the surface of the sculpture, to its durable yet painterly skin. A focus on surface has been a constant in Oldenburg's sculpture: from the distressed surfaces of works for *The Street* (1960) through the dribbled paint of those for *The Store* (1961) to the canvas of the soft sculptures, the gleam of those in vinyl, and a whole variety of textures in subsequent decades.

The finished outdoor sculptures for the château have a largeness of scale that relates both to the park at Beaumont-sur-Dême and to the artists' awareness of the generous dimensions of plants in California. But the means by which forms are enlarged is often digital technology, and the artists maintain a deliberate balance between a sense of the natural world and frank exposure of the works' industrial fabrication. Oldenburg and van Bruggen find forms in nature—in its widest sense—to which they apply their own aesthetic. They identify attributes that, while strengthening the originating form, also link it unexpectedly to other aspects of life. The sculptures they have placed outdoors at Beaumont-sur-Dême bring allusions to the indoor and the manufactured into play with the park's long vistas and open skies. They thus continue, in transmuted form, the long-established convention of follies and statues in the landscaped garden. Combining a light touch with positioning that enables the effect of each image to carry to its fullest across the setting, these incongruous objects enrich a world of sights, sound, and movement in the park that was already complex, in actuality as well as in imagination.

Oldenburg and van Bruggen see the château's surroundings as a sequence of contrasting zones. The ample terrace and the view that fans out from it are akin to an opera stage. The entrance facade faces a wood that could be from *A Midsummer Night's Dream*. The opposite view from the house, down toward the river, is the site of Happenings, as animals both wild and domesticated arrive and pass from view. The adjacent village is like the set for a realist drama. The gates to the château might swing open, like curtains in a theater, to disclose a stage on which the life of the village would unfold. The whole domain resounds with a continuous concert, of owls, cockerels, winds, church bells, and the sounds of cultivation. It is a conversation of the senses, in which the brightly colored new sculptures play a prominent part.

A PARK IN PORTUGAL

For the summer of 2001 these outdoor sculptures were transplanted to a very different parkland setting when, as part of the city's role as a European City of Culture for the year, the Museu Serralves in Porto, Portugal, presented a major exhibition of Oldenburg and van Bruggen, displayed both outdoors and in.[6]

Near the museum building is a clearing of almost unbroken green. There, surrounded by small, medium, and huge conifers, a 21-foot-high sculpture of one heart balanced on another, from which a tall, smokelike puff of cloud flutters toward the sky, provided a brilliant accent of contrasting red and white (Fig. 7). Much enlarged, it represents the bottle, bulb, and spray of an imaginary perfume bottle, conceived by Oldenburg as a Valentine's Day gift to van Bruggen. On one level the image, with its freely curling tube through which the perfume passes en route to atomization, is almost abstract. Yet this exuberant dance of shapes culminates in a joyous emission that is not only an extraordinary motif for a public sculpture, but also, like the first and last works in the present exhibition, a striking symbol of the artists' love.

Some key areas of the park at Serralves are severely formal. At one end of a long rectangular lawn another white configuration, the *Architect's Handkerchief* (1999), burst from a containing form, this time like a flower. The most difficult of all these outdoor sculptures to "read," it typified them in being an unexpected incursion of concentrated vitality into a setting of great calm; yet it was perfectly in keeping with the park's theme of the opening and closing of natural forms. Halfway along a nearby formal avenue of slender, mature trees one encountered, startlingly, *Corridor Pin, Blue* (1999), a giant safety pin balancing on its clasp. Unexpectedly, it was open. Thus high above one's head the unsheathed, near-horizontal pin pointed imperiously across the landscape with seeming, albeit enigmatic, urgency. The trees here are liquidambar, thus giving the exhibition its title and forming a further link both with the park at Beaumont-sur-Dême (where van Bruggen has planted an allée of this species) and with California, where

these large-scale works were made (and where the artists are familiar with a lane of liquidambar trees).

The avenue leads to the most emphatically formal of all the Serralves spaces, the Central Garden, with its Art Deco scheme of lawns, topiary, and pink paths divided by ranks of brilliant red flowers, rigidly positioned. Improbably sited on the piers at the top of the stairs leading down from the terrace were twin slices of blueberry pie, resting on scoops of ice cream (Fig. 8). The poise with which these overflowing slices were balanced, upright, was explained by their titles, *Shuttlecock/Blueberry Pies, I and II*. The view from the terrace culminated in a glimpse of the elbow and prong of a second giant safety pin, *Corridor Pin, Red* (1999). The sculpture's placement on a small circular vantage point for viewing the landscape beyond accentuated the pins' character as frames that reveal vistas through their near-rectilinear apertures. At ground level, the confinement of the site encouraged visitors to examine the lowest section of the work close-up and thus to appreciate the almost erotic conjunction of the two sides of the pin's clasp. From here one looked downward onto a mysterious lake. On its far bank, a slice of blueberry pie had opened, becoming a bird in flight.

Penetrating the earth decisively was the exhibition's keynote sculpture, *Plantoir* (2001; Fig. 9). This work is an emblem of the creativity at Beaumont-sur-Dême, as well as of the continuous activity that enables the park at Serralves to retain its ordered design. An implement of this type is also symbolic of the artists' relationship. Their collaboration began with the installation of *Trowel I* (1971–76), first in one park in the Netherlands and then in another, the work's permanent home, the Rijksmuseum Kröller-Müller, Otterlo, where the monochrome blue form rises more than 38 feet above the ground. *Plantoir* shows, in a sense, two stages in a process simultaneously, for while it penetrates the soil in order to plant it, its form is that of an already unfolding flower.[7] There is a connection between this organic metaphor and the intense red of the *Plantoir's* scoop, a color chosen by van Bruggen for its emotional resonance and signaling a deeper register of feeling than in the cooler *Trowel I*.

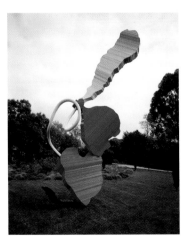

Fig. 7:
Claes Oldenburg and Coosje van Bruggen
Valentine Perfume, 1997
Stainless steel, cast aluminum, aluminum pipe; painted with acrylic urethane, 21' x 4' 9" x 9' 4"
Fabricated by Tallix, Beacon, New York
Sited at Museu Serralves, Porto

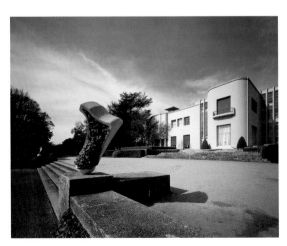

Fig. 8:
Claes Oldenburg and Coosje van Bruggen
Shuttlecock/Blueberry Pies, I and II, 1999
Cast aluminum painted with acrylic urethane, each 48 x 24 x 24"
Fabricated by Tallix, Beacon, New York
Sited at Museu Serralves, Porto

FLOATING PEEL

Plantoir focuses on a decisive physical action that initiates disruption so as to make future pleasure possible. *Resonances, after J. V.* (which is also linked to *Plantoir* through the motif of a trowel on one of the "Delft tiles") and *Balzac/Pétanque*, the culminating sculpture in the present exhibition, both do the same. So, too, does the tallest work in the exhibition, *Floating Peel* (2002; pp. 26–27). Though made after the Serralves exhibition, the *Peel* extends the engagement with air and space implicit in all the sculptures made for outdoor settings.

An important theme of Oldenburg's work has always been the pull of gravity and its effects. He is fascinated also by its antithesis, but the concern with flight and with taking off that is so evident in his and van Bruggen's joint work comes more especially from her imagination. This concern is particularly overt in *Floating Peel*, which draws strongly on van Bruggen's experiences in childhood. Casually flung away, a banana skin flies through the air, its configuration combining exuberance with grace. Caught at a moment of infinitely precarious balance between its parts, it presents the most extreme state of poise possible without the structure collapsing. Techniques of aircraft manufacture were employed to achieve this balance. This is curiously appropriate as the concept was first developed by the artists for Schipol Airport in Amsterdam. Though that project was not realized, the associations with aircraft propeller and windmill vane present in the original idea remain in the finished sculpture. The horizontal sections of peel flex gently, yet the work as a whole conveys the sensation of accelerating through space, while opening up for the viewer the shifting planes of a construction that combines overall simplicity with considerable complexity in detail.

Floating Peel embodies van Bruggen's memory of the elegant arcs she described when skating on Dutch canals. But vital here is the sense of speed with which van Bruggen has imbued the sculpture. The image incorporates her recollection of the dynamic motion of speed skating around the curve of a rink. Paradoxically, it also captures her delight, as a young ballet dancer, at balancing on the toe, elevated for only a moment, yet a moment of extraordinary freedom and exhilaration. The banana skin is caught at a split second in its trajectory. In everyday life we experience occasional flashes of insight elusive in nature, difficult to attain and impossible to retain, except in imagination. Underlying the concern with instants of time that links many of Oldenburg and van Bruggen's sculptures is the wish to make concrete the magic of such moments that look both forward and back. *Resonances, after J. V.* does this. It is like a snapshot taken as love runs its course in a music room in seventeenth-century Delft, yet equally it celebrates Vermeer's ability to make objects speak of the human condition in any era. *Floating Peel*, too, compresses powerful memories. In this exhibition it leads toward a final work—*Balzac/Pétanque* (2002; see pocket, inside front cover)—that does the same as it looks back to nineteenth-century France.

THE LOIRE VALLEY

Beaumont-sur-Dême is in the northern part of Touraine, through which the Loire River flows. Fruit, the principal motif of *Balzac/Pétanque*, plays a major role in both the economy and the gastronomy of the region. Long an important subject in art, food has been prominent in Oldenburg's work in particular for over forty years. In 1964 the food his sculptures represented was specifically French. For an exhibition at the Galerie Ileana Sonnabend in Paris he created a group of sculptures of food made of plaster of Paris. The refined, painterly image of a work such as *Viandes [Meat]* strongly recalls the art of Chardin, while other sculptures in the group highlight the invitation to indulgence that is the essence of elegantly presented French *patisseries*.

There is a natural affinity between the delight in appearance, taste, smell, and touch implicit in all these works (as in Oldenburg and van Bruggen's art in general) and the long tradition of the celebration of these qualities in the literature of the Loire region. A leading example is the work of François Rabelais (d. 1553), of whom Terence Cave has observed that "the exuberant linguistic inventiveness of his writing…creates

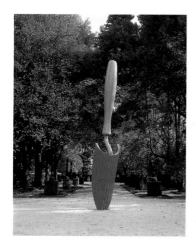

Fig. 9:
Claes Oldenburg and Coosje van Bruggen
Plantoir 2/3, 2001
Stainless steel, aluminum, and fiber-reinforced plastic; painted with polyurethane enamel, 23' 11" x 4' 5" x 4' 9"
Fabricated by Carlson & Co., San Fernando, California
Sited at Museu Serralves, Porto

a self-contained imaginative world in which...real events and problems...are transformed and transcended,"[8] and that his "emphasis on eating, drinking, and other bodily activities should be seen, not as some kind of outdated schoolboy humour, but as a vigorous and far-reaching attempt to portray human nature as a whole."[9] The work of Oldenburg and van Bruggen is consistent with these aims, as is the Rabelaisian directness of their pleasure, in *Balzac/Pétanque*, in fruit cultivated in their region.[10] Love and nature are also important themes in the work of the great poet Pierre de Ronsard (1524–1585), who lived in the Loire Valley.

Respectively to the south and north of Beaumont-sur-Dême are key locations in the life and work of George Sand (1804–1876), at Nohant, and of Marcel Proust (1871–1922), at Illiers/Combray. It was an item of food, a madeleine, that for Proust had the power to bring back the past, beginning with the intense memories it evoked of this region. A sense of the potency of this small baked delicacy underlies the sketch in which it is discovered, enlarged, leaning against a tree in the park at Beaumont-sur-Dême (Fig. 10). But of all the region's great writers it is Honoré de Balzac (1799–1850) to whom, in *Balzac/Pétanque*, the artists pay homage—the Balzac who imitated Rabelais,[11] only to be himself both imitated and defended by Proust, the "vast plan" of whose *À la recherche du temps perdu* was influenced by that of Balzac's *La Comédie Humaine*;[12] the Balzac, too, who followed Ronsard in immortalizing the landscape and produce of Touraine, and who was a friend of George Sand.

BALZAC

Though van Bruggen is an art historian, her key field of study was French literature; the literary stereotypes that play a part in the artists' work emanate from her. Van Bruggen's student research into the work of nineteenth-century French poets, including Baudelaire and Verlaine, gave rise to a keen response to their period as a whole, and this interest expanded naturally to include the novels of the somewhat older Balzac. One outcome is the largest work in this exhibition, which

began as an idea for an image that van Bruggen conceived and offered to Oldenburg to develop visually.

In his writing, Balzac sought instinctively to take account of everything he encountered or knew of, and not only to embrace the whole world but to reveal the interconnectedness of all its parts. As Graham Robb has observed: "His metaphorical mind was incapable of perceiving a fact in isolation; pulling at the smallest impression invariably brought up the whole root system."[13] These qualities, which are echoed in Oldenburg and van Bruggen's own art, would almost certainly have led to the influence from Balzac's essentially generous vision of life, a likelihood ensured by the artists' establishment of a home in the Loire region. As Robb also writes: "The lasting significance of Balzac's first experience of Paris lies in his return to what he came to consider as his true mother—the Loire Valley. Leaving the grime of Paris for Touraine in early spring was a revelation. These days imprinted themselves in Balzac's mind so deeply that they recur in his novels throughout his life."[14]

Oldenburg and van Bruggen visualize their works first in the form of drawings (p. 36). They conceived *Balzac/Pétanque* not only as a striking indoor sculpture, but also as a proposal for a monument to the writer (p. 38), to be sited in a square in Tours, the city of his birth. The vividness of Balzac's evocation of the fecundity of nature in the region of which Tours is the heart gives the monument's imagery a special aptness in this location. Though unlike Rodin's superb visualization of Balzac (Fig. 11), which offers a naturalistic image of its subject, *Balzac/Pétanque* is consistent with all of Oldenburg and van Bruggen's monuments to individuals in representing its subject by means of attributes. In the case of Balzac, the chosen attribute is peaches and pears. Also crucial is the attendant knife, for Oldenburg and van Bruggen focus on an act central to Balzac's enjoyment of life, the *consumption* of fruit. Of special inspiration in the conception of this sculpture was an eyewitness account of such an episode:

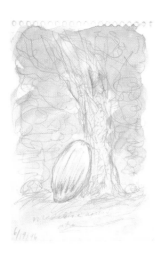

Fig. 10:
Claes Oldenburg and Coosje van Bruggen
from *Sketchbook: Sculpture for the Park (with J.V.)*, 1996
Pencil, colored pencil, watercolor, 6 3/8 x 4"

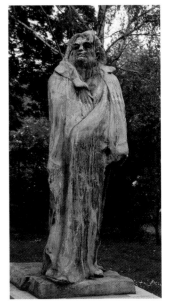

Fig. 11:
Auguste Rodin
Balzac, 1897
Bronze
Musée Rodin, Paris

...his lips quivered, his eyes shone with happiness, his hands twitched with pleasurable anticipation at sight of a pyramid of beautiful pears or peaches....He was magnificent in his flamboyant, Pantagruelian way; he had removed his cravat and his short collar was open; with a fruit knife in his hand he laughed, drank, and carved into the juicy flesh of a large pear....[15]

Prolific though he was, Balzac's publishers found it extraordinarily difficult to extract manuscripts from him. Robb relates how on one occasion Edmond Werdet "hurried all the way to Nemours to collect a long-overdue manuscript, only to be told that Balzac had spent the weekend pruning fruit trees."[16] Moreover: "Pear was the dominant smell in his Passy retreat according to Nerval, and at one point his pear reserves reached 1,500."[17] As Robb observes in the same passage: "In any account of Balzac's life his stomach would be one of the heroes....Feasting for Balzac was partly a spectator sport, until it came to the fruit course," when he would home in on what he himself described, in *Les Paysans*, as "those twisted, desiccated fruits with black patches that gourmets know from experience and under whose skins Nature enjoys placing exquisite tastes and odours."

The use of pears to evoke an individual recalls irresistibly the devastating lithographs in which Daumier employs the fruit to represent the French king Louis-Philippe. *Gargantua* (1831), in which the king's already pear-shaped head sits atop a naturalistic body, has been described as "a scatological caricature of Rabelaisian inspiration."[18] In *Masks of 1831*,[19] fourteen precisely delineated faces of politicians surround the image of a single pear that, though uncaptioned, would have been recognized by contemporaries as representing the king, even though his facial features are barely visible. By the time of *Heave-ho!...Heave-ho! Heave-ho!* (1832), the king, "now completely transformed into a pear, is 'executed' by hanging by the bell-ringers of the people, who make him chime out like a giant bell."[20] Édouard Papet identifies an impulse to portray universal types as common to Daumier and Balzac, who were born only nine years apart.[21]

Daumier's work as a whole was seen by Baudelaire as a complement to Balzac's *La Comédie Humaine*,[22] and Ségolène Le Men has described Daumier as Balzac's best illustrator.[23] In admiring Daumier's ability to condense an idea or person in a visual metaphor, Balzac was identifying a gift possessed not only by himself but also by Oldenburg and van Bruggen, who conceive his monument as a celebration of the abundance of nature.

Balzac/Pétanque presents the classically stable structure of a pyramid, yet visualizes it as destabilized by the novelist's actions. Curiously, when Balzac was ten his father had been "the first person to think of erecting a pyramid in front of the Louvre."[24] In an image that again associates stability with its opposite, Balzac described his father as "the Pyramid of Egypt, immovable, even as the planet falls apart around him."[25] For the artists, the appeal of the pyramid lies partly in the interest in primary objects that runs throughout their work (and which they shared with their friend Donald Judd). Most of their versions of everyday motifs are constructed by combining a number of such forms to give maximum concentration to the image. Oldenburg's *Bedroom Ensemble* (fig. 4) is a gathering of such forms, destabilized by deliberate oddities of perspective.

Providing a parallel to the juxtaposition of a pyramid of rounded forms with a knife is Oldenburg's *Proposed Colossal Monument for Stockholm: Knife in Pyramid of Butter Balls* (1966; Fig. 12). Familiar from the artists' individual memories of the gastronomic cultures of both Sweden and the Netherlands, the motif of butter balls contributed to the thinking that led to *Balzac/Pétanque*. In each work, the factor that gives life to so classic a form as the pyramid is the inclusion of elements that imply movement and change; a sense of finality is thus undermined. This fundamental principle of the art of Oldenburg and van Bruggen is specially appropriate in the case of a monument to Balzac. As Robb states: "Critics adhering to classical principles would pass negative judgment on Balzac's work...[for] his novels lack the smug sufficiency of the perfectly finished product....they retain and radiate the will power...that produced them."[26] Van Bruggen has remarked recently that Balzac "never got rid of the impu-

Fig. 12
Claes Oldenburg
Proposed Colossal Monument for Stockholm:
Knife in Pyramid of Butter Balls, 1966
Pencil, 8 1/4 x 11 5/8"

rities in his style, despite endless rewritings of his texts. I am sympathetic to such a pure-impure mixture, for it relates to our dynamics of transforming stereotypes."[27] Among the sources of their works' openness and unpredictability is the way each of the artists' thoughts intrudes on the other's while the concept of sculpture evolves and is brought to realization.

FRUITFUL VISIONS

Among the best-known images of pyramids of fruit in art are those of the eighteenth-century French painter Chardin. Part of the power of these still lifes, which are much admired by Oldenburg and van Bruggen for the way in which everyday motifs are pared down to essentials, lies in their gravity and, indeed, their very stillness. Yet for the artists such pictures gain added interest from the potential for change, movement, and even collapse implicit in their conception. Set in pantry, kitchen, or dining room, they all point to imminent transformation by human action. Even were that not so, the stability of the arrangements we are shown is threatened not only by decay but by the closeness of objects to the edges of shelves or tables or by the keen interest of dogs and cats in the meat, game, and fish on display. For Oldenburg and van Bruggen the pyramid in still life is of interest as being a given, a tradition within the genre, but it is all the more compelling for them in Chardin because he exposes that stereotype to the threat of disarray.

One of the most spectacular of Chardin's pictures of a pyramid of fruit is *The Buffet* (1728; Fig. 13). Prominent in the composition, as in *Balzac/Pétanque*, are peaches, pears, a white tablecloth, and a knife. Chardin juxtaposed a pyramid of fruit with a knife in several pictures, and though other painters did the same, his knives seem more purposeful, less incidental. This sense of the actuality of use is emphasized by the way in which, as in *The Buffet*, Chardin's knives protrude over the edges of the surfaces on which they lie. In *The White Tablecloth* (c. 1732; The Art Institute of Chicago), the protruding knife lies on a white tablecloth that bears a blue line and a fallen drinking glass. This and *The Buffet* are among Chardin's largest works.

Chardin's pictures give a sense of immediacy to the fruit and knives disposed on surfaces and to the pleasure of food. A century later these qualities are seen in French painting with renewed vividness, in the numerous Impressionist still lifes in which the setting is the open air. In *Balzac/Pétanque* it is impossible to escape the image of Balzac at table, yet the work's imagined setting is at least as much alfresco. Fruits and knife rest on and around a white napkin or tablecloth, the central elements of the composition being loosely framed by the fabric's narrow blue border. Along with the appeal of ripe fruit, such an arrangement evokes the pleasure of human company in an ambience of warmth and light.

In an important early precedent, Manet's *Déjeuner sur l'herbe* (1863), fruit spills onto discarded garments, but three years later in Monet's picture of the same title in the Musée d'Orsay (Fig. 14), pears and peaches are among the fruits that lie, adjacent to a knife, on a large white tablecloth. All three of the great *Bathers* paintings from the end of Cézanne's career must represent picnics, for in two of them fruit is prominent in the foreground (in at least one case on a tablecloth or napkin), while in the third the central figures are laying a cloth on the ground.[28] In the astonishing issue of these pictures, Picasso's *Demoiselles d'Avignon* (1907; Museum of Modern Art, New York), fruit lies on a similar white fabric, between viewer and women.

The present exhibition begins and ends with works in which a scene that was originally controlled is presented in a state of disorder. We are shown the aftermath of an event we did not witness, but whose nature is implicit in what we see. However, whereas the turbulence in *Resonances, after J. V.* has taken place under the visible aegis of love's personification, in *Balzac/Pétanque* an affective interpretation hinges on suggestions in the imagery's form and context.

Manet's *Déjeuner sur l'herbe*, with its nude woman seated between men, and Picasso's *Demoiselles*, set in a brothel, associate foregrounded fruit with relations between the sexes. Nothing so definite can be said about Cézanne's late *Bathers*, yet it certainly can be said about two of his own (so-titled) versions of the theme of *Déjeuner sur l'herbe*[29]

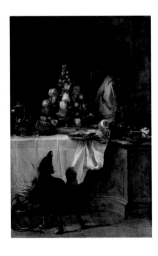

Fig. 13:
Jean–Baptiste Simeon Chardin
The Buffet, 1728
Oil on canvas, 76 5/8 x 50 3/4"
Musée du Louvre, Paris

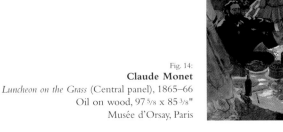

Fig. 14:
Claude Monet
Luncheon on the Grass (Central panel), 1865–66
Oil on wood, 97 5/8 x 85 3/8"
Musée d'Orsay, Paris

(especially the later in date), both of which center on white tablecloths supporting fruit. Also set outdoors (though not on the grass), the same artist's *L'Orgie (Le Festin)* of c. 1870,[30] likewise centers on fruit on a white tablecloth. It is therefore interesting that in Cézanne's *Still Life with Cupid* (1894–95; Fig. 15), pears and peaches are piled at the feet of this symbolic figure, as if in tribute to the powers of the god of love.

In the absence of any figure, the effect of *Balzac/Pétanque* is to make us examine more closely the fruits that, disposed on and around the "stage" of the tablecloth, are the actors in this work. Their ripe forms and seductive colors emphasize the fecundity of nature, but also put us in mind of Picasso's use of fruit forms to represent his mistress, Marie-Thérèse Walter (Fig. 16).[31] There is an affinity between this erotic anthropomorphism and Oldenburg's observation that "one can speak of the sexuality of an object."[32] This preoccupation of Oldenburg's can be traced back at least as far as *The Store*, his extraordinary creation on New York's Lower East Side in 1961.

Balzac/Pétanque takes us at once farther back and farther forward in time. Conceived in and for the Loire Valley, it evokes the range of the appetites experienced in the region in the nineteenth century by the pear-loving novelist of whom Robb writes: "His walks in the countryside [correspond] in nearly all of Balzac's brilliant Touraine landscapes to a sexual awakening."[33] But it also celebrates the artists' own response, in nearby Beaumont-sur-Dême, to the sensuous fullness of nature and also, in the distinctly gendered forms of the two chosen fruits, to each other.

SPORT IN FRANCE

Like Balzac, Oldenburg and van Bruggen work in both city and country, and it has already been observed how their art reflects both contexts. Robert L. Herbert has demonstrated how the country picnics painted by the Impressionists, today so redolent of unspoiled nature, were in reality an aspect of life in the city.[34] In *Balzac/Pétanque*, Oldenburg and van Bruggen reinforce this duality by associating luscious country fruits with the unpredictability and collisions of a pastime pursued throughout France—but in cities, towns, and villages rather than in the landscape.

It was natural to connect Balzac's appetite for fruit to the picnics enjoyed in the mid-nineteenth century, in which fruit played so central a role. Moreover, it was not only Balzac's appetite that implied the disintegration of the pyramid of peaches and pears. For in picnics on the grass, pyramids of fruit are impractical and in Impressionist picnics fruits roll across uneven surfaces. This image suggested to Oldenburg and van Bruggen the disorderly scattering of balls in the national recreation of *pétanque* (also called *boules*).

In introducing this theme into their still life, Oldenburg and van Bruggen typically revitalize a familiar motif by exposing it to an unexpected disruptive force. In *pétanque*, balls of three sizes are thrown along a course of sand or grit (hence the sandy setting of *Balzac/Pétanque* in the present exhibition). The first ball thrown, which is of wood, is the smallest and forms the target, while the others are metal, the largest number being small but heavy *boules* in polished steel. Seeking to ensure that one of their own *boules* ends up closest to the target, players often use one *boule* forcefully to displace others that have already come to rest. Impact and change are at the heart of the game. The notion of the ruin of Balzac's pyramid by hostile lobs recalls the demolition job attempted on his reputation by many critics in his lifetime, but the references in *Balzac/Pétanque* are wider in scope. As van Bruggen has explained: "The association with...*la pétanque*...jolts the imagination. The appearance of having been struck gives trajectories to the pears and peaches. The focus on the moment of impact and scattering creates the dynamic of the piece and its metamorphic qualities."[35]

The target in *pétanque* does not resemble a pyramid. But pool, curiously, another game of skill involving the propulsion of balls over a surface, begins when one ball is aimed at others that have been arranged to form a triangle. For Braque, one of the great poets of fruits, napkin, and knife, the table in the closely related game of billiards was another important motif. Oldenburg himself had earlier explored the

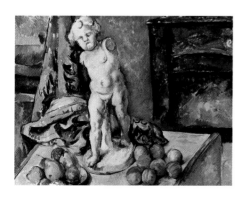

Fig. 15:
Paul Cézanne
Still Life with Cupid, 1894–95
Oil on canvas, 24 3/4 x 31 7/8"
Nationalmuseum Stockholm

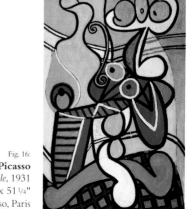

Fig. 16:
Pablo Picasso
Large Still Life with a Pedestal Table, 1931
Oil on canvas, 76 3/4 x 51 1/4"
Musée Picasso, Paris

potential of balls arranged in a triangle and then dispersed across a surface. There is an analogy between his *Giant Pool Balls* (Fig. 17) and *Balzac/Pétanque*, in that the spheres in the earlier work can be displayed either with fifteen in a neat triangle, with a sixteenth resting loose beside it, or dispersed across the floor but with their triangular rack leaning against the wall, thus reasserting their formal starting point in the appearance of a pyramid. These alternative modes of displaying the work can, however, never be seen together, whereas *Balzac/Pétanque* presents a bold architectural structure simultaneously with the scattering of its parts through violent impact.

In *Balzac/Pétanque* the artists have increased the scale of the peaches and pears from that observed by Balzac to one where individual fruits are waist high. The image constitutes an environment or small piazza, in which the disintegration of the pyramid is experienced more startlingly than in either a meal or a game of skill. In each of two recent works realized on an environmental scale, Oldenburg and van Bruggen again anticipate *Balzac/Pétanque* by combining such disorientating new perspectives with brilliant color and with the effects of violent movement. The first of these, *Dropped Bowl with Scattered Slices and Peels* (1990; Fig. 18), installed in the Metro-Dade Open Space Park in Miami, has colors similar to *Balzac/Pétanque* and also has a motif of fruit. 105 feet in its longest dimension, it includes eight bowl fragments, four peels, and five orange sections. The other, *Flying Pins* (2000; Fig. 19), installed on Kennedylaan in Eindhoven in the Netherlands, connects closely with *Balzac/Pétanque* in its presentation of the violent impact of a ball in a game played on a long track. As well as the thrown ball (complete with finger holes) used in ten-pin bowling, the sculpture shows all ten skittles immediately after the moment of impact, three of them still in mid-air and easy to walk under.

Like these related works and all other sculptures created by the artists since they began working together, *Balzac/Pétanque* is the product of a collaboration between Oldenburg and van Bruggen that contradicts the idea of separate roles. In such a narrow view, van Bruggen would be the source of ideas and Oldenburg the creator of their visible appearance. The work did indeed begin in this way, but once Oldenburg's initial drawing had given the image a vivid reality on paper its form developed through a joint dialogue. At the fabrication stage, van Bruggen played an equal part with Oldenburg in the process of digital enlargement and in decisions on structural materials. Realizing the image in three dimensions involved different considerations from the drawn visualization. As the sculpture took form, van Bruggen defined the composition of the decomposing pyramid and its scattered pieces and determined the exact position of each fruit.

Crucial to a sculpture's effect are decisions on color, which articulates the forms and determines how the work will be read, both in its environmental setting and in its emotional import. For *Balzac/Pétanque*, van Bruggen formulated a technique of nearly transparent layers of resin washes, brushstrokes applied by Oldenburg, and sprayed paint, in order to achieve a likeness to watercolor, even as open-air durability was maintained. Visually strong from afar, the surface of each fruit becomes almost immaterial close up. Such delicacy of effect is not normally associated with factory process. It is as though this sculpture, inspired in part by the outdoor images of Impressionist painting, is an image not only of fruit, napkin, and knife, but also of one of the innumerable *plein-air* watercolors that Impressionism inspired. Like the interior after Vermeer, it is a play on conventions. If the artists realize their hope of siting it in Tours, their *image* of still life in landscape will come full circle, finally becoming a still life in actual landscape.

DISSOLUTION AND CONTINUITY

Just as the enduring form of the pyramid is destroyed in *Balzac/Pétanque* by implied human action, so in the work's fiction the fruits of which it was composed are destined themselves to be degraded, even if uneaten, by the processes of nature. Indicators of a particular season, they make us aware of the cycle of the year. The sculpture's theme, the dissolution of what started out as a strongly defined form, exhibits a preoccupation that runs throughout Oldenburg

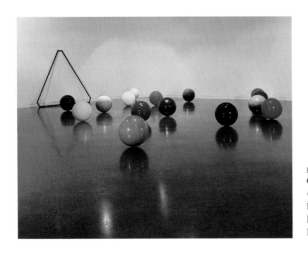

Fig. 17:
Claes Oldenburg
Giant Pool Balls, 1967
Plexiglas with metal rack. Sixteen balls, each 24" diameter; overall: 2 x 10 x 9'
Los Angeles County Museum of Art, Anonymous Gift through the Contemporary Art Council
Installed at the Pasadena Art Museum, December 7, 1971–February 6, 1972

and van Bruggen's work, namely, with changes of state that signify both extinction and renewal. Thus like many of their works, *Balzac/Pétanque* is a metaphor not only for an annual cycle, but for the cycle of life itself.

Consistent with this concern, *Balzac/Pétanque* also highlights the simultaneous assertion (again made by most of Oldenburg and van Bruggen's work) of hard and soft, stable and unstable. The fruits here have a hard material finality, industrially fashioned, yet we think of them as both yielding and transient. Their image of spilling abundance recalls the same motif in the strongly structured still lifes of Cézanne, in which, as here, observed reality was adjusted so as not only to affirm solidity, but also to charge the composition with a stimulating vitality. These qualities in *Balzac/Pétanque* would be writ still larger were the sculpture to be installed in front of the Hôtel de Ville at Tours. To the concept of a pyramid would be added the durability of a public monument; yet, bizarrely, the image set in front of a dignified civic architecture would be that of a structure in collapse. This would, however, be an appropriate way of commemorating Balzac. For while he showed how fragile is life and how fleeting are the pleasures of the senses, he showed, too, that the instinct to enjoy such pleasures is permanent and inextinguishable.

A FLIGHT OF FANCY

In a sculpture that offers so lively an interplay between the fixed and the unstable, we should finally consider the lowest-lying element. Like the numerous *fruits/boules*, the cloth in *Balzac/Pétanque*, spread out on a notional table or grass, also has a dual identity. Supporting a manifest pileup of solid objects, one feels that it at least must be securely grounded. Yet van Bruggen, entranced in childhood by *The Thousand and One Nights* (commonly known as *The Arabian Nights*), determined at an early point that the cloth should also have the character of a flying carpet, able magically to transport its passengers to other times and places.[36] This, perhaps, is why the cloth has shifting locations—on the table at which Balzac eats his pyramid of fruit; on the grass at Impressionist picnics in the half century after Balzac's

death; and as a substitute for the gritty terrain on which *pétanque*—invented only in 1910—is still played throughout France. The introduction of magic is consistent with Oldenburg and van Bruggen's inspiration from the park at Beaumont-sur-Dême. As we have seen, time collapses there, and the artists see the park as inhabited by the mysterious objects embodied both in their sculptures and in Oldenburg's sketches. In some of the latter, moreover, trees are actually *turning into* other things—giant paintbrushes, inverted torsos, or wood nymphs.

In the quarter century since Oldenburg and van Bruggen's partnership began, the theme of flight has recurred increasingly in their art. A classic example is the several versions of the improbable *Blueberry Pie, Flying*, of the late 1990s. Another is the giant *Shuttlecocks* of 1994, installed on the lawn of The Nelson-Atkins Museum of Art in Kansas City. The two motifs come together in the twin *Shuttlecock/Blueberry Pies* of 1999, which perch on either side of the steps at Beaumont-sur-Dême that lead from terrace to park. This image anticipates *Balzac/Pétanque* in combining flight, landing, fruit, spheres, and the idea of something being sliced into. But it also connects with the quality of enigma that is another ingredient of the new sculpture. For the form of the shuttlecock is inseparable, for van Bruggen, from that of the carved stone sphinxes on a war memorial in Kansas City, which have veiled their faces with their wings. Oldenburg has drawn a number of *Shuttlecock/Sphinxes* that relate both to these and to the sculptures of sphinxes in the gardens of the château of Chenonceau in the Loire Valley. The artists regard each of these drawn sphinxes as representing a different season. These enigmatic creatures embody or respond to the forces of nature. In the no less enigmatic *Balzac/Pétanque*, it is the addition of movement—itself a natural force—that unlooses the effects. As in all of the artists' works, shape and form are articulated cleanly, yet movement introduces a creative confusion, opening up the work in terms of both meaning and feeling.

There is a connection between the artists' recurrent interest in flight or floating and all the works in this exhibition. *Balzac/Pétanque* may be the only one to represent continuing

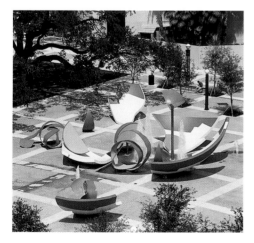

Fig. 18:
Claes Oldenburg and Coosje van Bruggen
Dropped Bowl with Scattered Slices and Peels, 1990
Stainless steel, steel, reinforced concrete, fiber-reinforced plastic; painted with polyurethane enamel. Seventeen parts (eight bowl fragments, four peels, five orange sections) in an area approximately 16' 9" x 91' x 105'
Metro-Dade Open Space Park, Miami
Fabricated by Lippincott, Inc., North Haven, Connecticut;
Merrifield-Roberts, Inc., Bristol, Rhode Island.

flight, but from the slackening that follows the firing of Cupid's arrow in *Resonances, after J. V.* through the relaxed state of the large individual musical instruments to the liberation of the banana implied in *Floating Peel*, a common factor is delight in the sensation of release.[37] This quality is present in *Balzac/Pétanque* in the dissolution of the formal structure of the pyramid, as well as in the work's capacity to become airborne. *Floating Peel*, too, is in a kind of flight, for the sculpture visualizes the peel on its way to ground, after the banana eater has flung it away. The gentle swaying of its 13-foot-high structure acts, in this exhibition, as a prelude to the flying carpet in the final room.

The capacity of a magic carpet to collapse distance and time (in a manner comparable to a dissolve in film) relates to the principle at work in *Resonances, after J. V.*, by which the artists were able to pass without interruption from the seventeenth to the twenty-first century. Intense emotion experienced in both eras coalesces, so that the unifying factor is feeling. In each work in the exhibition, the play of emotion is synonymous with the breaking open of something previously enclosed, intact, or controlled—the conventions of polite society in seventeenth-century Delft, the "defenses" of the woman whose heart is struck by Cupid's arrow, the integrity of each musical instrument, the form of the banana, the decorum of the fashionable picnic, the perfection of the pyramid of fruit, and the sense of hierarchy in human society that the pyramid symbolizes. In each case it is the human touch that has wrought the change, initiating a rite of passage. The invariable outcome is a state of imperfection. Oldenburg and van Bruggen acknowledge this in their work as the condition of life today. Far from being escapist, their art reflects contemporary experience; however, in dismantling familiar things they do not violate their motif but rather liberate it, creating a new thing that is open to response and interpretation as it takes its place in the world.

Each of the works in this exhibition is like a window on time. The window is opened by the jolt of surprise that associates imagery strongly recalling the past with the experience of here and now. In *Resonances, after J. V.*, Rietveld's modernist chair is a key agent of this effect. In *Balzac/Pétanque*,

thought is led forward in steps of time, from Balzac's feast to the later context of the Impressionist picnic and then, startlingly, to the twentieth-century sport of *pétanque*. The resulting sense of collision coincides with one in which a vista opens up. Players of *pétanque* throw a metal ball into the air. This movement through space leads naturally to the image of the flying carpet, with its freedom to link different times and places. As these analogies imply, a central message of *Balzac/Pétanque*—as of *Resonances, after J. V.*—is that the impact of the insights embodied in a powerful work of art is not confined to the era in which it is made. The effect lasts indefinitely, but it needs a sense of contemporary reality to make it vital in the art of a later generation. Just as strange as what went long before, this reality can help us perceive, through art, that the seeming strangeness of the past once represented normality.

Floating Peel and the first and last works in this installation are linked by the image of fruit. Peaches and pears are the motif of the design on the curtain in *Resonances, after J. V.* and also one of the motifs on the tiles in that sculpture. The recurrence of this subject is a token of the growing degree to which Oldenburg and van Bruggen draw inspiration for their work directly from the natural world. This influence nourishes them in concert with that of the culture of the past, which is also of increasing importance to their art. We have seen how in each sculpture the artists accord a crucial role to disruption. It is therefore paradoxical that the qualities that are intensifying in their work—the natural and the traditional—denote strongly the value of continuity and of reflection. The clarity and concentration of each of Oldenburg and van Bruggen's images gives their sculptures a striking immediate impact, but this leads, for the viewer, to a slower and steadier unfolding of the work's rich metaphorical content. It leads, as well, to a delighted savoring of the world of feeling and sensation.

– Richard Morphet

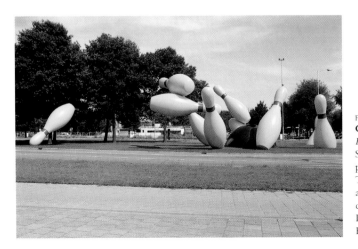

Fig. 19:
Claes Oldenburg and Coosje van Bruggen
Flying Pins, 2000
Steel, fiber-reinforced plastic, foam, epoxy;
painted with polyester gelcoat and polyurethane enamel
Ten pins, each 24' 7" high x 7' 7" widest diameter, in an area
approximately 123' long x 65' 7" wide; including partially buried pins,
combined pins, individual pins, and ball: 9' 2" high x 21' 12" diameter
Intersection of John F. Kennedylaan and Fellenoord Avenues, Eindhoven, the Netherlands
Fabricated by William Kreysler and Associates, American Canyon, California

ENDNOTES

1. *Resonances, after J. V.* was first shown in the National Gallery's exhibition "Encounters: New Art from Old," June–September 2000, and is the subject of the present author's essay, on pp. 250–61 of the catalogue.

2. For example, *A Lady at the Virginal with a Gentleman (The Music Lesson)*, in The Royal Collection, London.

3. Ellen H. Johnson, *Claes Oldenburg* (Harmondsworth, U.K.: Penguin Books [New Art 4], 1971), p. 27.

4. All the works in the present exhibition can be related to the opening words of Shakespeare's *Twelfth Night*: "If music be the food of love, play on." Every work by Oldenburg and van Bruggen involves the selection of a stereotype that is given new life by unexpected recontextualization. While the stereotypes are most frequently everyday objects, Shakespeare's words remind us that stereotypes can also be literary.

5. See Claes Oldenburg and Coosje van Bruggen, *Large-Scale Projects* (London: Thames & Hudson, 1995).

6. "Down Liquidambar Lane: Sculptures in the Park," May–October 2001 (extended to November). A related book, published in 2002, includes an essay by Richard Cork, "Into the Woods," and "Down Liquidambar Lane: A Conversation between Coosje van Bruggen, Claes Oldenburg, and Alexandre Melo."

7. The artists' work as a whole relates to that of the pioneer German photographer of architectonic plant forms, Karl Blossfeldt (1865–1932).

8. Terence Cave, in Peter France, ed., *The New Oxford Companion to Literature in French* (London: Clarendon Press; New York: Oxford University Press, 1995), p. 665.

9. Ibid., p. 596.

10. Cf. the following passage in Rabelais (Rabelais, *Gargantua and Pantagruel*, transl. J. M.Cohen [Harmondsworth, U.K.: Penguin Books, 1955], p. 565.):

 When the meal was quite finished, Greatclod gave us a large quantity of fine, fat pears, saying as he did so: "Take these, my friends. They are singularly good pears, and you won't find them as good elsewhere. Not every land grows everything....Set some seedlings from them if you like, in your own country."

 "What do you call them?" asked Pantagruel. "They seem excellent to me, and they have a fine flavour...."

 "We just call them pears," answered Greatclod. "We're simple folk, as it pleased God to make us. "We call figs figs, plums plums, and pears pears."

 "Indeed," said Pantagruel. "When I get back home—and pray God it be soon—I'll plant and graft some of them in my garden in Touraine on the banks of the Loire...."

11. David Bellos, in Peter France, ed., *The New Oxford Companion to Literature in French*, p. 62.

12. George D. Painter, *Marcel Proust: A Biography* (London: Chatto & Windus, 1965), vol. 2, pp. 99–100, 102, 136.

13. Graham Robb, *Balzac* (1994; ed. London and Basingstoke, U.K.: Papermac, 1995), pp. 170–71.

14. Ibid., p. 30.

15. Léon Gozlan, quoted in Stefan Zweig, *Balzac*, transl. William and Dorothy Rose, Book 2, "Balzac at Work" (New York: Viking Press, 1946), pp. 113–14.

16. Robb, *Balzac*, p. 274.

17. Ibid., p. 347.

18. Ségolène Le Men, in *Daumier*, exh. cat. (Ottawa: National Gallery of Canada, 1999), pp. 76–77 (where *Gargantua* is reproduced as no. 5).

19. Ibid., no. 7, p. 79.

20. Ibid., no. 8, p. 81.

21. Ibid., p. 89.

22. Cited by Henri Loyrette, ibid., p. 18.

23. Ibid., p. 40.

24. Robb, *Balzac*, p. 33.

25. Ibid., p. 78.

26. Ibid., p. 42.

27. "Down Liquidambar Lane: A Conversation Between Coosje van Bruggen, Claes Oldenburg, and Alexandre Melo," in *Down Liquidambar Lane: Sculptures in the Park* (Porto: Museu Serralves, 2002), p. 69.

28. It has often been remarked how the structure of these paintings is based on the triangle. Cézanne's concern with a stability dependent (as in the pyramid) on a widening base is exemplified by his preoccupation with the motif of Mont Ste. Victoire.

29. *Le Déjeuner sur l'herbe* of c. 1870, and *Le Déjeuner sur l'herbe* of 1877–82, both private collection, reproduced in Mary Louise Krumrine, *Paul Cézanne: The Bathers* (1989; ed. London: Thames & Hudson, 1990), ills. 39 and 43.

30. Private collection, ibid., ill. 23.

31. Cf. William Rubin, "Reflections on Picasso and Portraiture," in *Picasso and Portraiture*, exh. cat. (New York: The Museum of Modern Art, 1996), pp. 67-69, and Robert Rosenblum, "Picasso's Blond Muse: The Reign of Marie-Thérèse Walter," ibid., p. 360 (Rosenblum's essay, p. 362, contains a reproduction of a 1917 postcard associating fruits, including peaches and a banana, with male and female body parts.)

32. Richard Kostelanetz, "Interview with Claes Oldenburg," in *The Theater of Mixed Means* (New York: Dial Press, 1968), p. 157.

33. Robb, *Balzac*, p. 30.

34. See Robert L. Herbert, *Impressionism: Art, Leisure and Parisian Society* (New Haven and London: Yale University Press, 1988), pp. 170–77.

35. "Down Liquidambar Lane: A Conversation between Coosje van Bruggen, Claes Oldenburg, and Alexandre Melo," p. 73.

36. One reason for introducing this motif was van Bruggen's awareness of the frequency with which Balzac refers to *The Arabian Nights* in *La Comédie Humaine*. On the incidence of flying carpets in *The Arabian Nights* and in twentieth-century film, see Robert Irwin, "Flying Carpets," in *Hali*, 109 (March–April 2000), p. 192.

37. This is the explicit subject of Oldenburg and van Bruggen's proposal for a sculpture in Stockholm, *Caught and Set Free* (1998), which shows a basketball at the moment of its escape from the net.

Resonances, after J. V., 2000
Wood, metal, urethane foam, canvas, cardboard, paper, washline, string, resin, acrylic enamel, pencil, crayon, watercolor
overall 58 $^{7}/_{16}$ x 55 $^{3}/_{16}$ x 16 $^{1}/_{8}$"; opening 46 x 54 $^{1}/_{4}$ x 16 $^{3}/_{4}$"

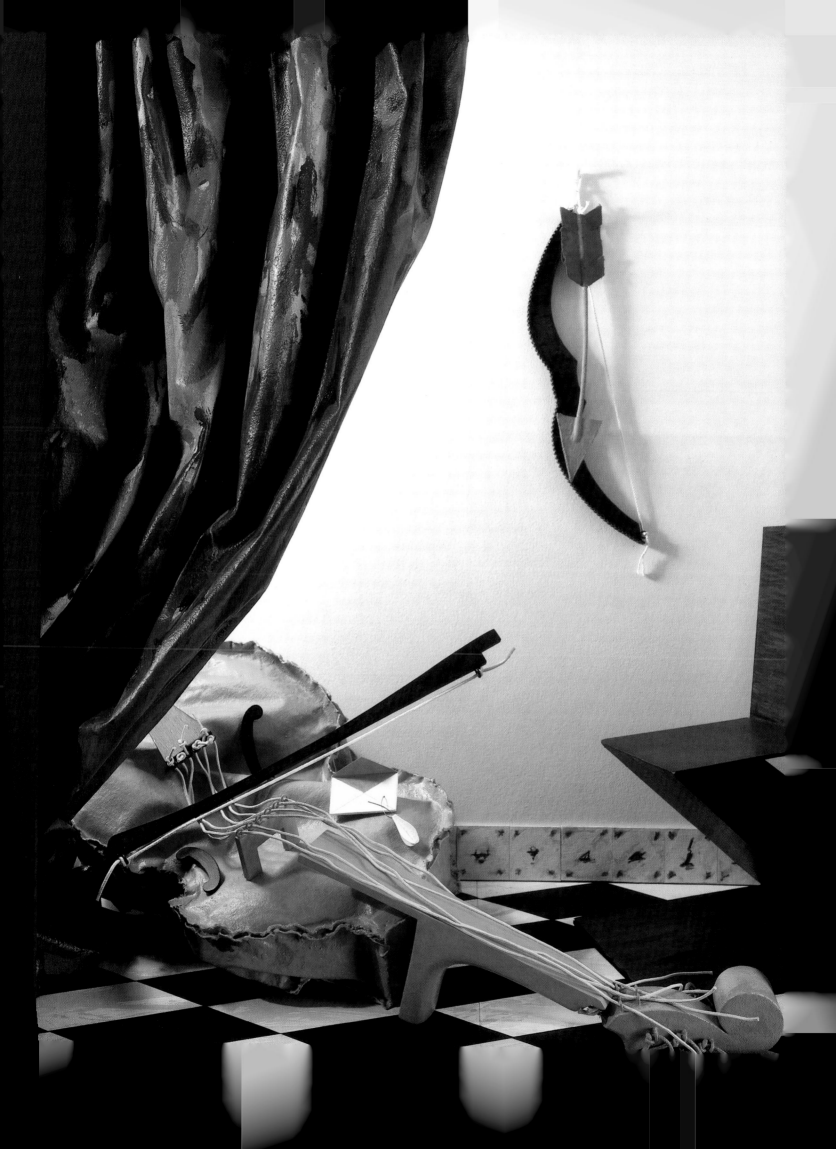

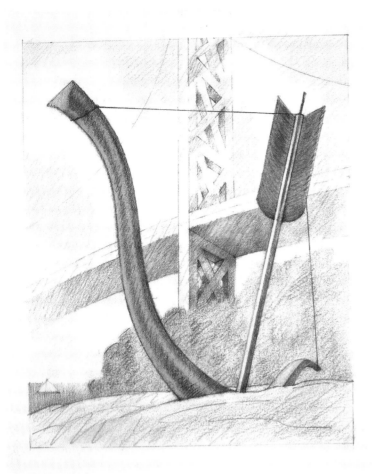

Cupid's Span, Sited in Rincon Park, San Francisco, 2000
Pencil and colored pencil
7 ³/₄ x 6 ³/₈"

detail of *Row of Tiles* from *Resonances, after J. V.*, 2000
Crayon and watercolor, mounted on balsa wood
each drawing 2 ³/₈ x 2 ³/₈"

detail from *Resonances, after J. V.*, 2000

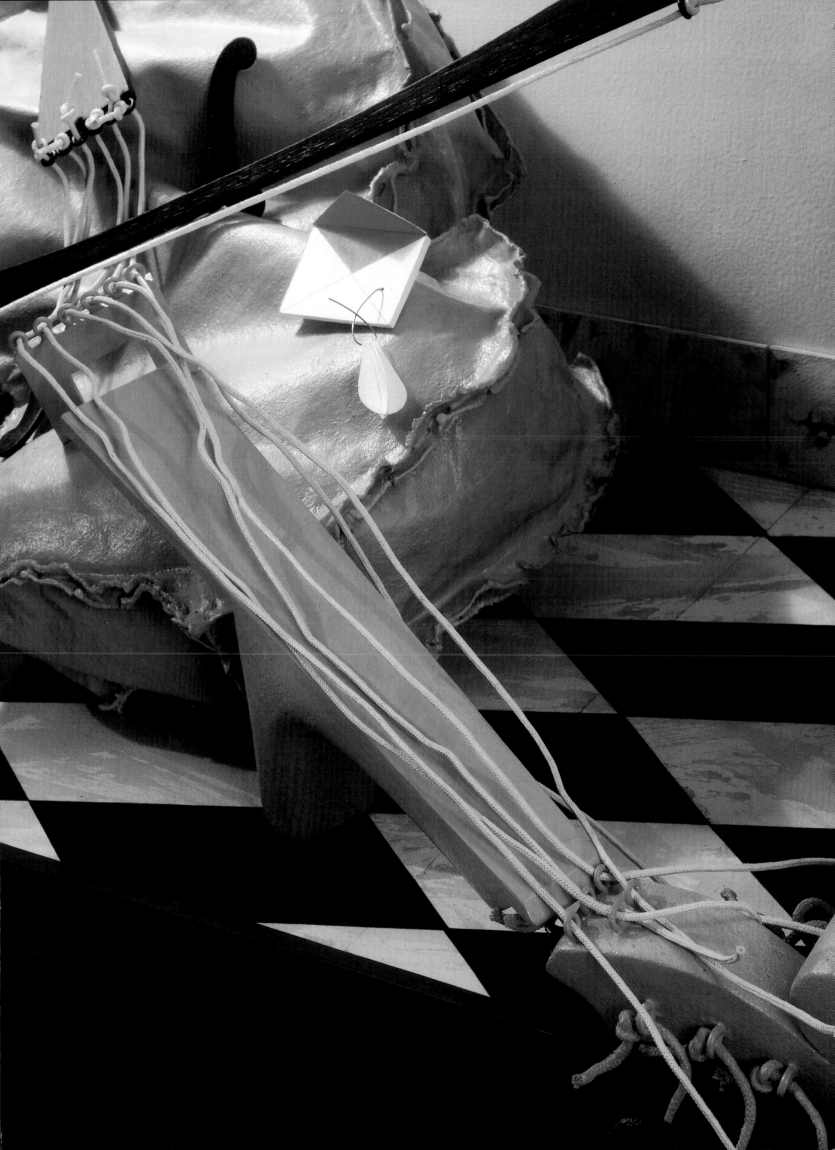

Soft Viola 1/2, 2002
Canvas and resin painted with latex
8' 8" x 5' x 1' 10", installation dimensions variable

Soft Viola 1/2, 2002
Canvas and resin painted with latex
8' 8" x 5' x 1' 10", installation dimensions variable

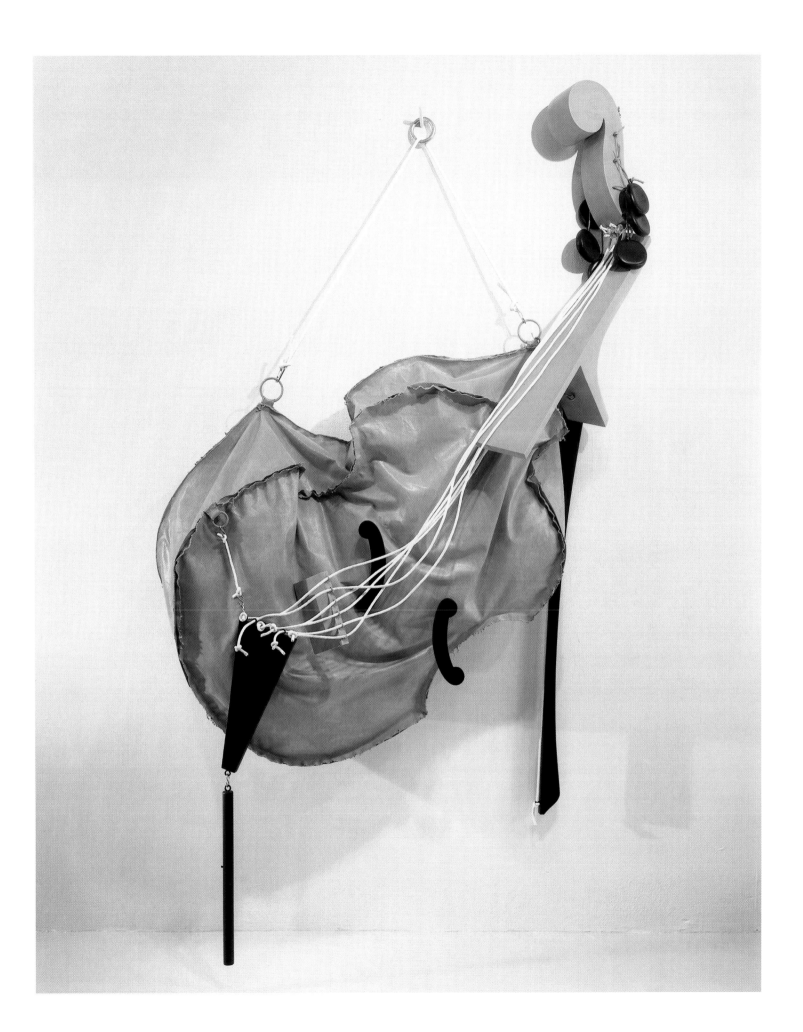

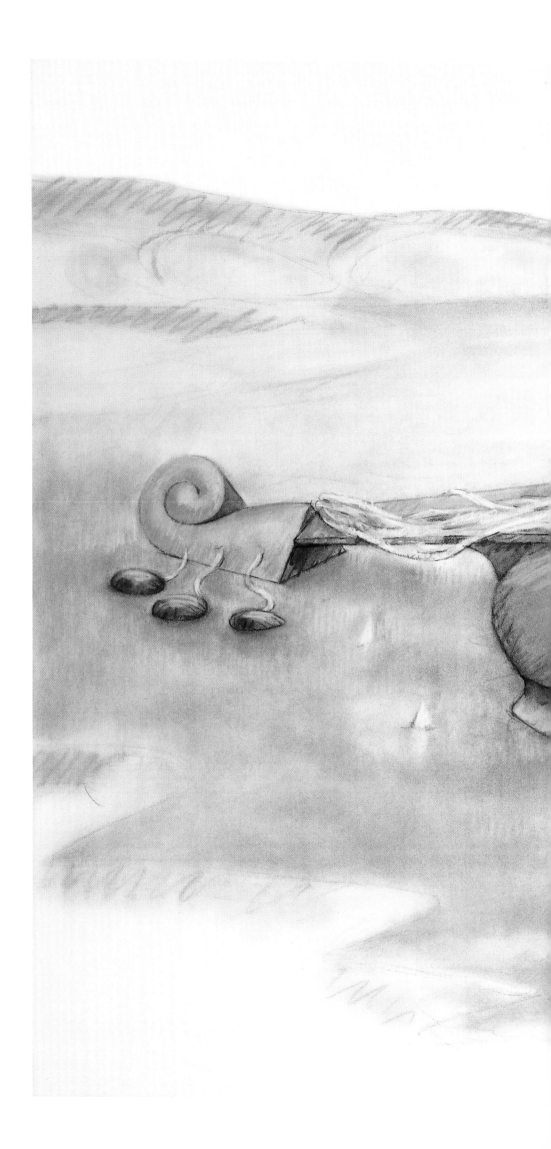

Soft Viola Island, 2001
Charcoal and pastel
34 x 46 1/2"

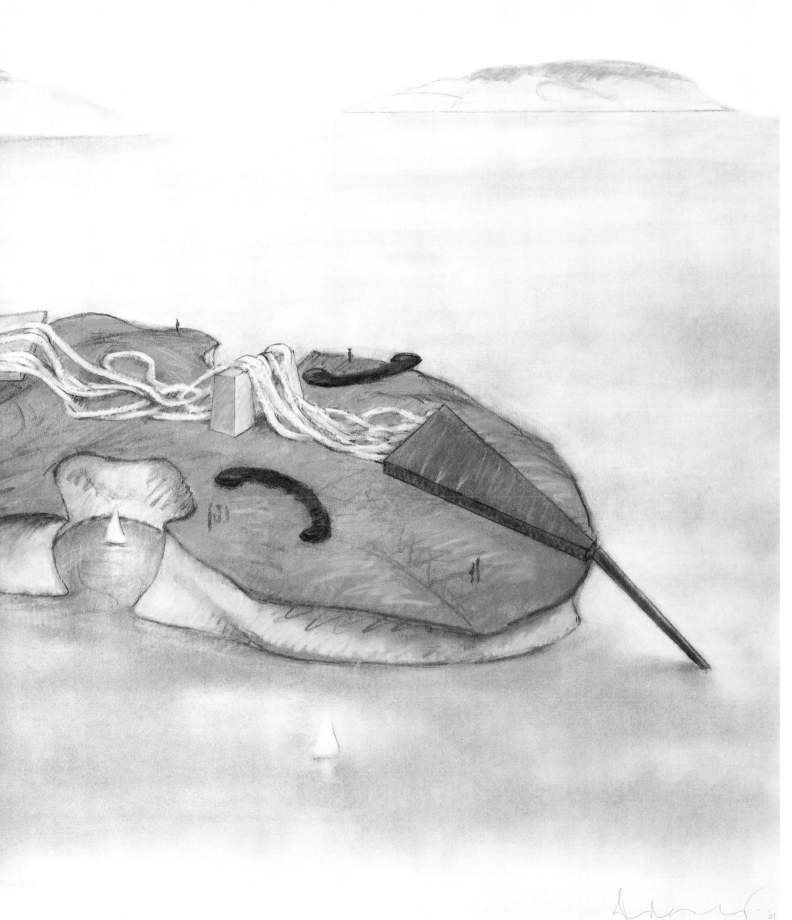

Floating Peel, 2002
Fiber-reinforced plastic painted with polyester gelcoat
13' 9" high

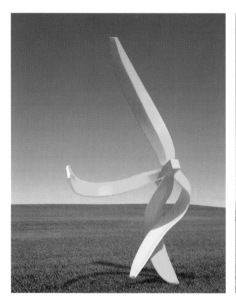 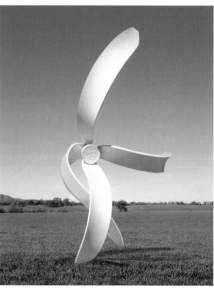 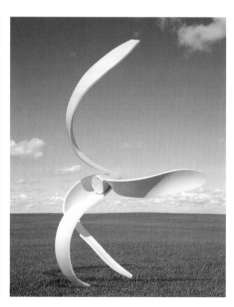

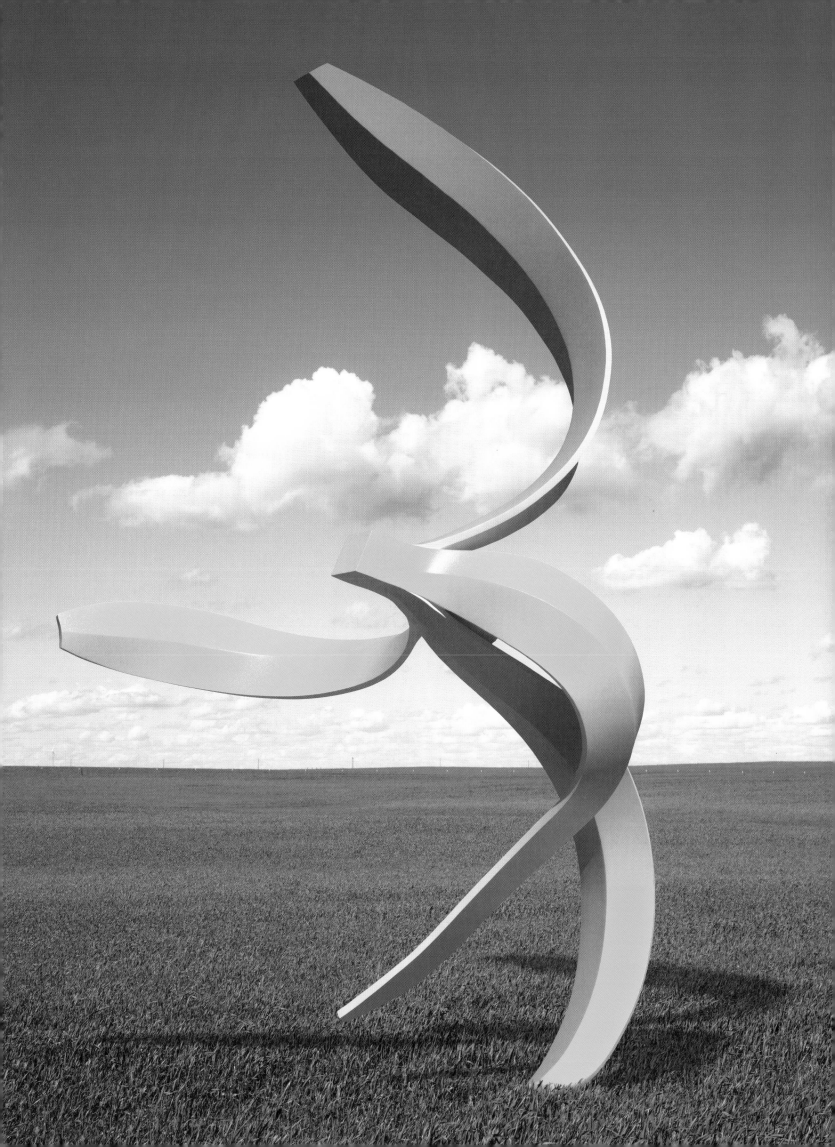

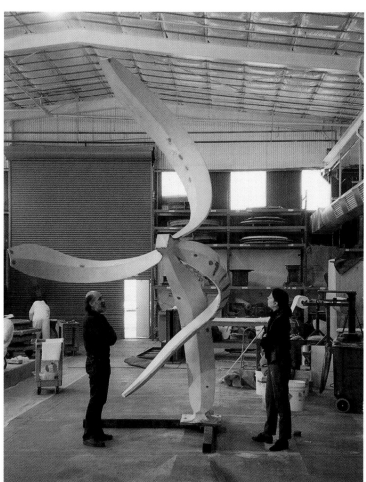

Floating Peel in progress at William Kreysler and Associates, American Canyon, California. Coosje van Bruggen and project manager Serge Labesque discuss texture and final paint coat.

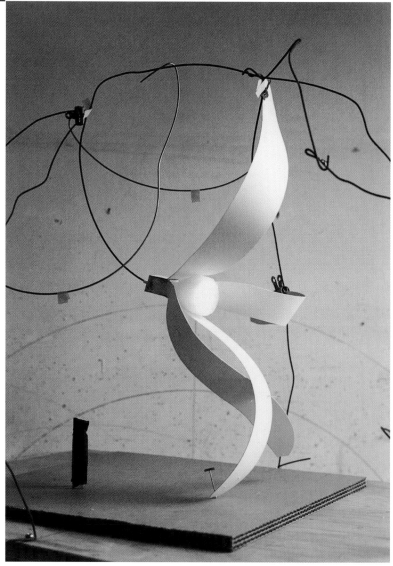

Position Study for Floating Peel, 1998 (destroyed)
Paper, wire, cardboard, expanded polystyrene
Dimensions unrecorded

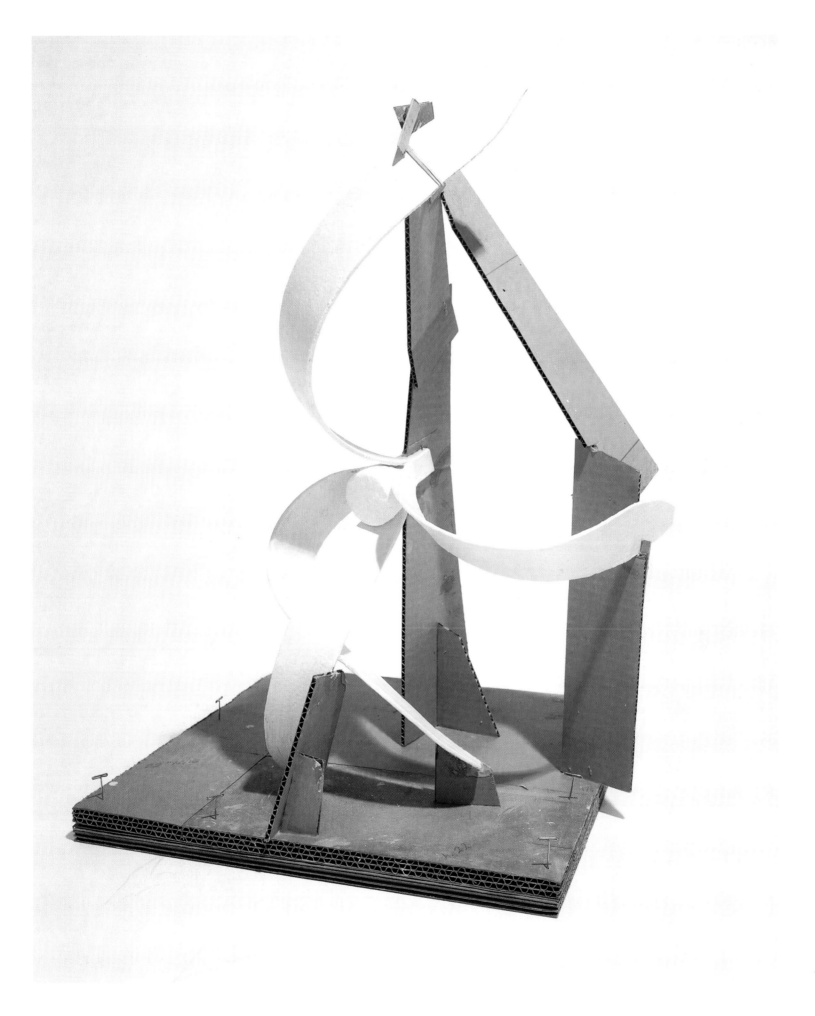

Floating Peel, Model, 1998
Felt, cardboard, expanded polystyrene, t-pins, resin, painted with polyurethane enamel
25 x 16 1/8 x 16"

Feasible Monument in the Form of Two Banana Peels, for Stockholm Harbor, 1997
Pencil and pastel
30 x 39 ¹/₂"

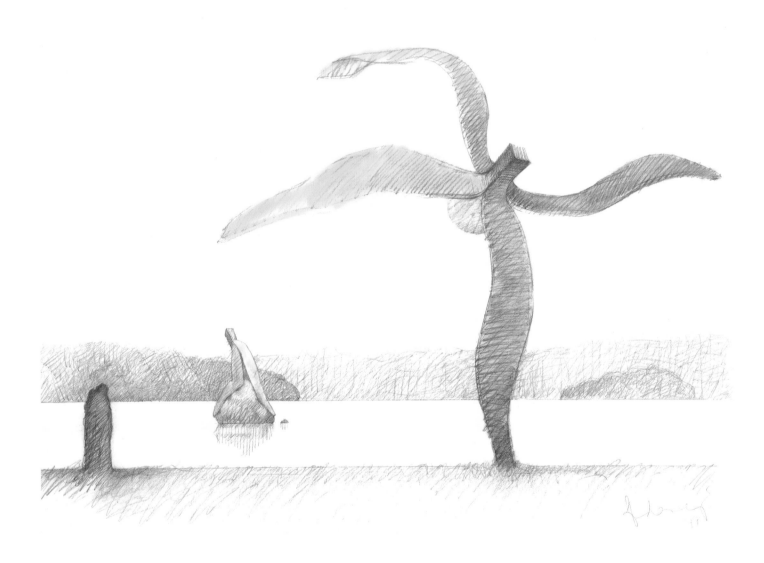

Proposal for a Lighthouse in the Form of a Banana Peel, for the Coast of New Zealand, 2001
Charcoal and pastel
28 ⁷/₈ x 22 ¹/₂"

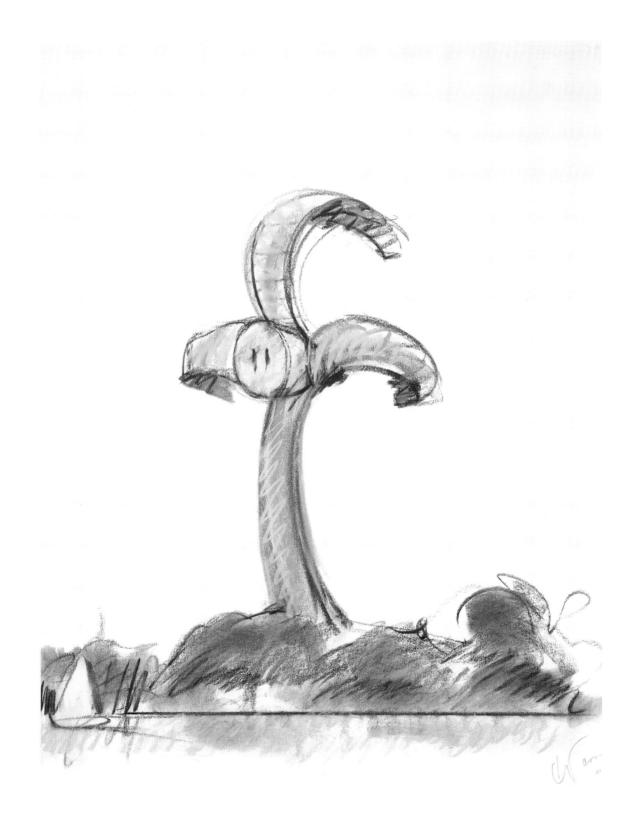

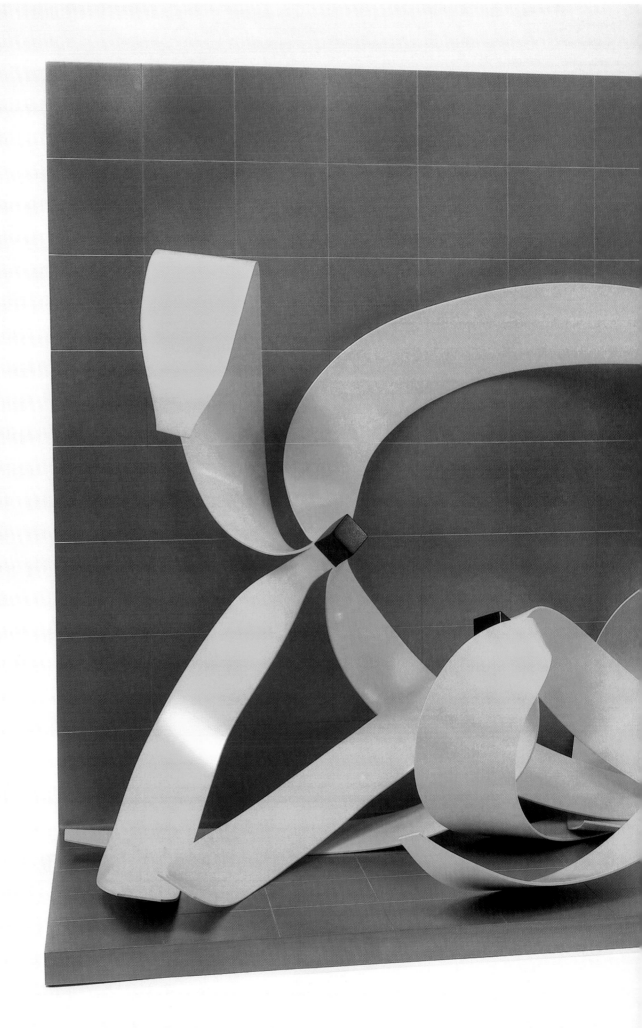

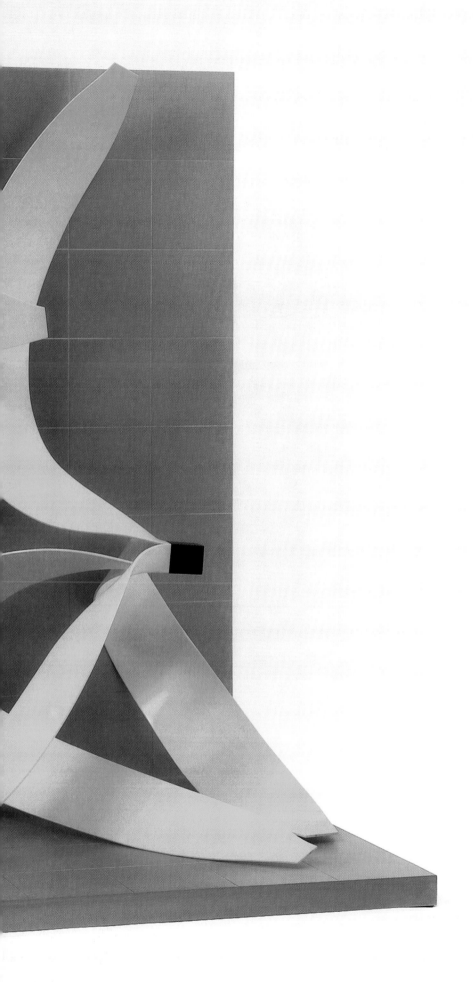

Flung Peels—Model for a Mural, 2002
Aluminum painted with acrylic urethane
37 x 23 ³/₄ x 45"

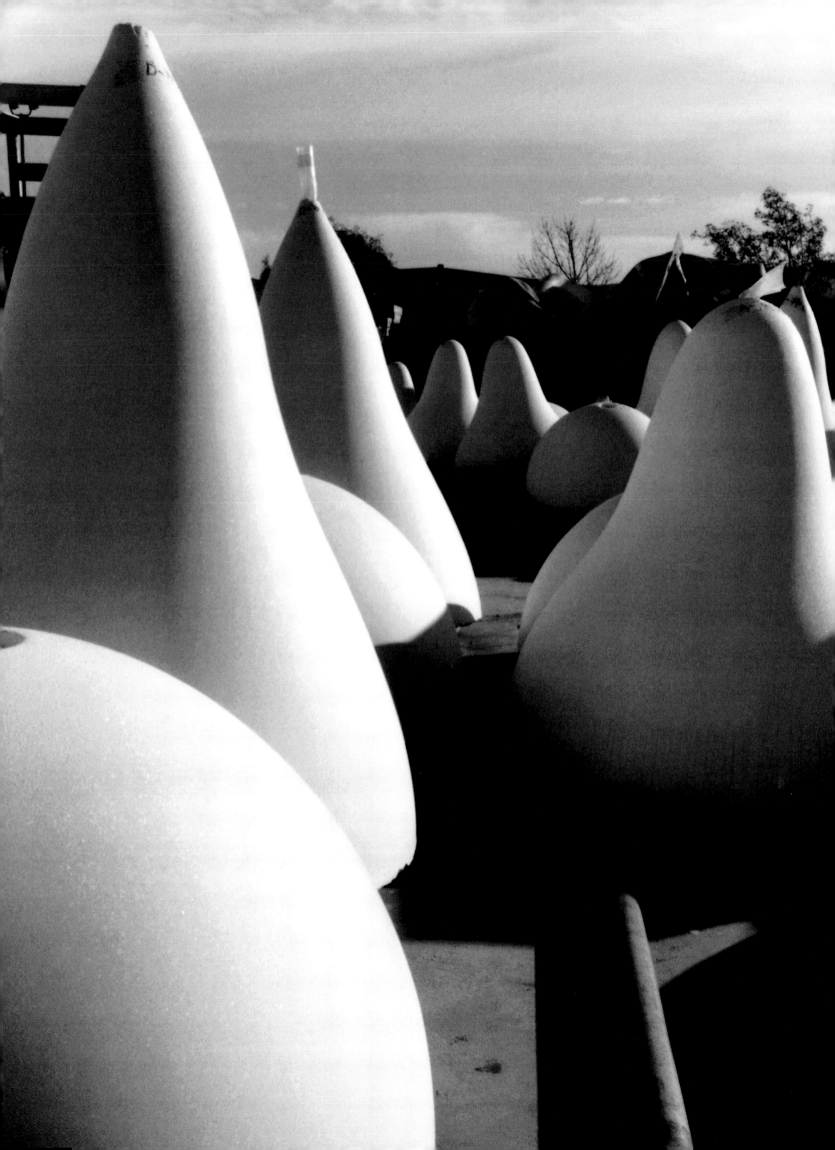

Balzac/Pétanque in progress at William Kreysler and Associates, American Canyon, California.

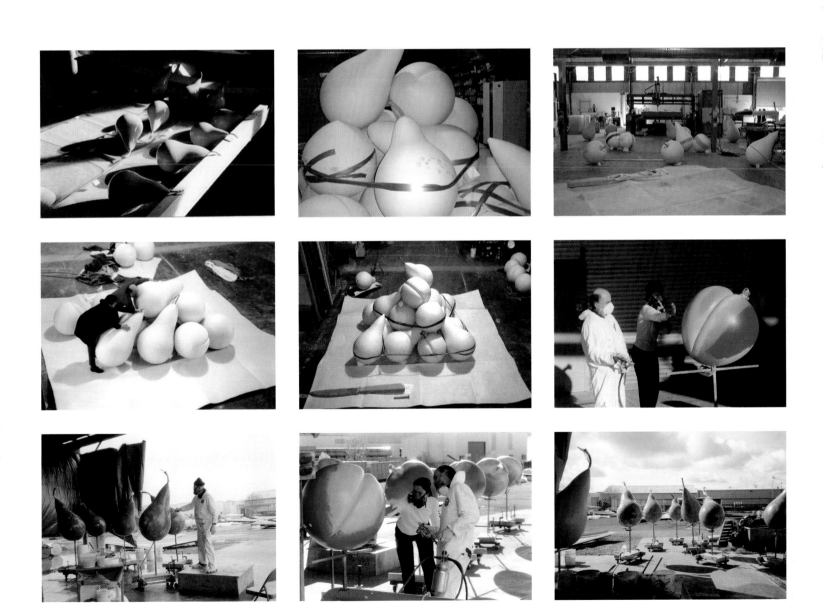

Pyramid of Pears and Peaches, Final Version, 1998
Charcoal and pastel
38 x 50"

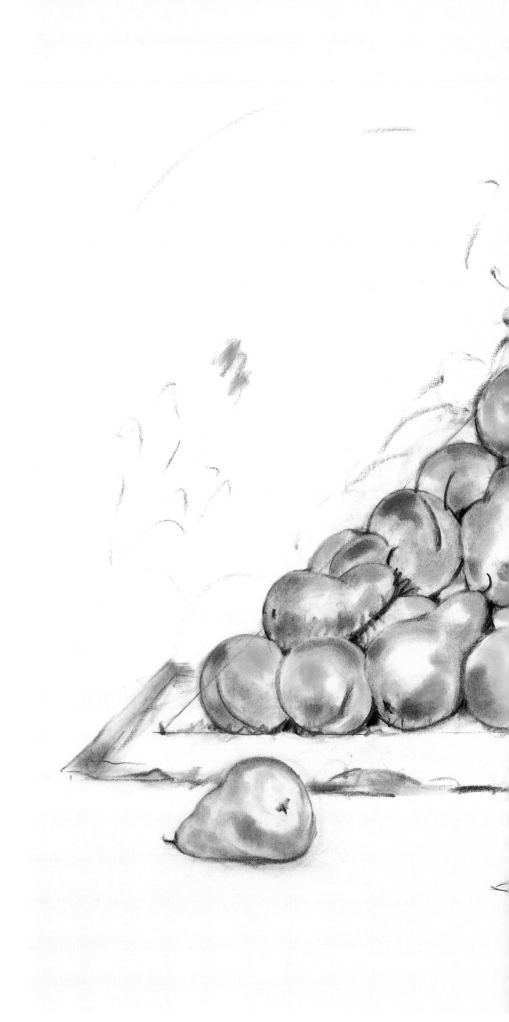

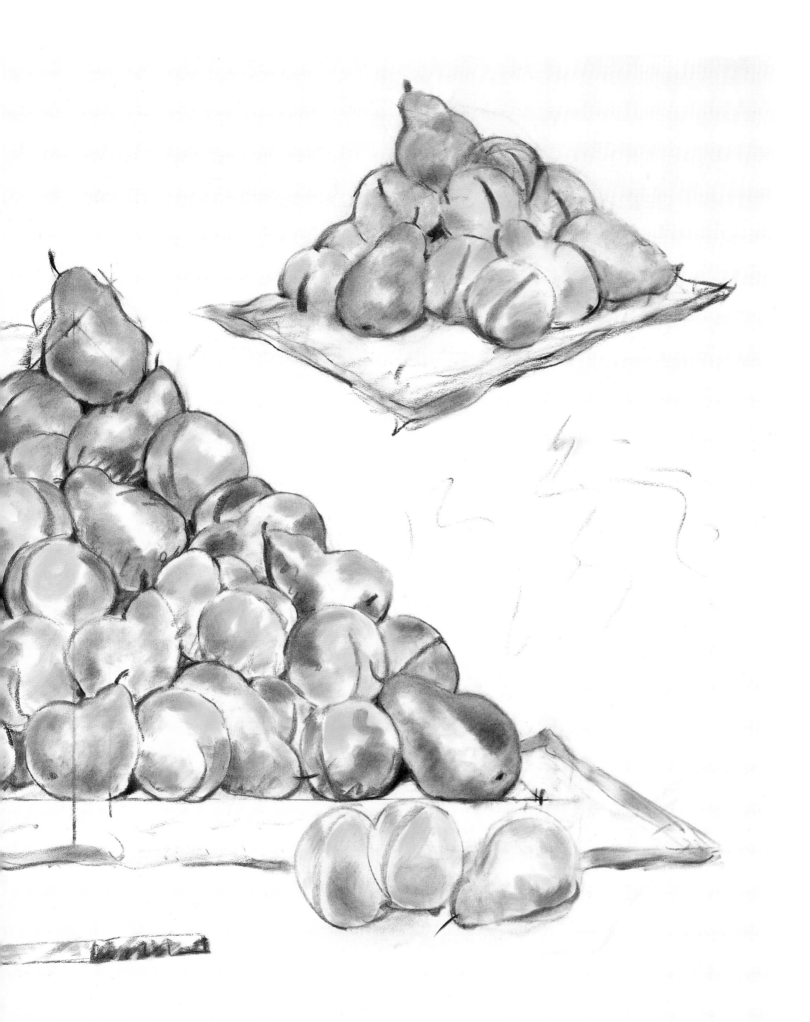

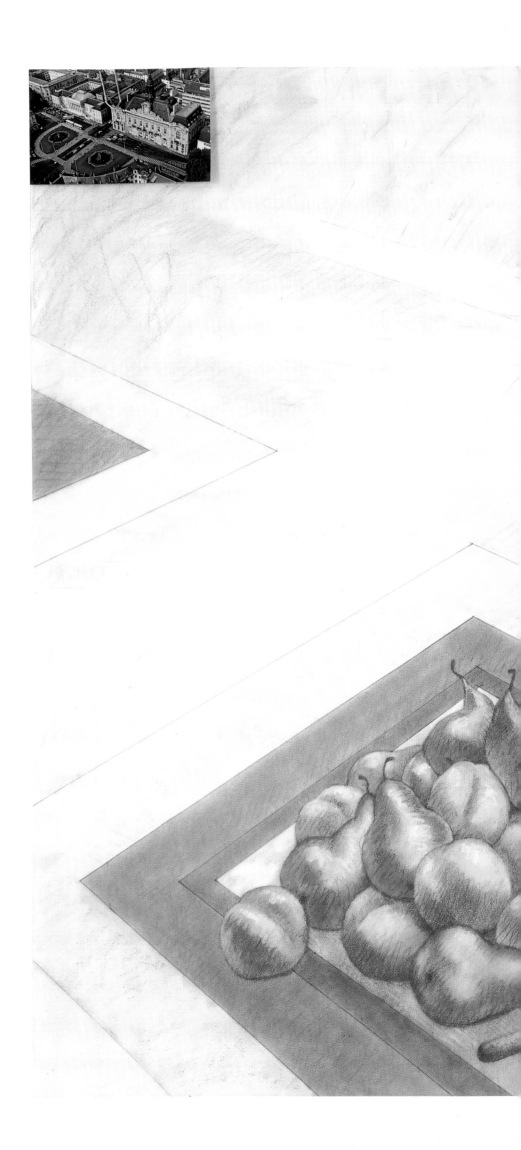

*Proposal for a Monument to Honoré
Balzac in the Form of a Pyramid of
Pears and Peaches, Place Jean Jaurès,
Tours, France*, 2000
Pencil, colored pencil, pastel, charcoal, postcard
30 x 39 ³/₄"

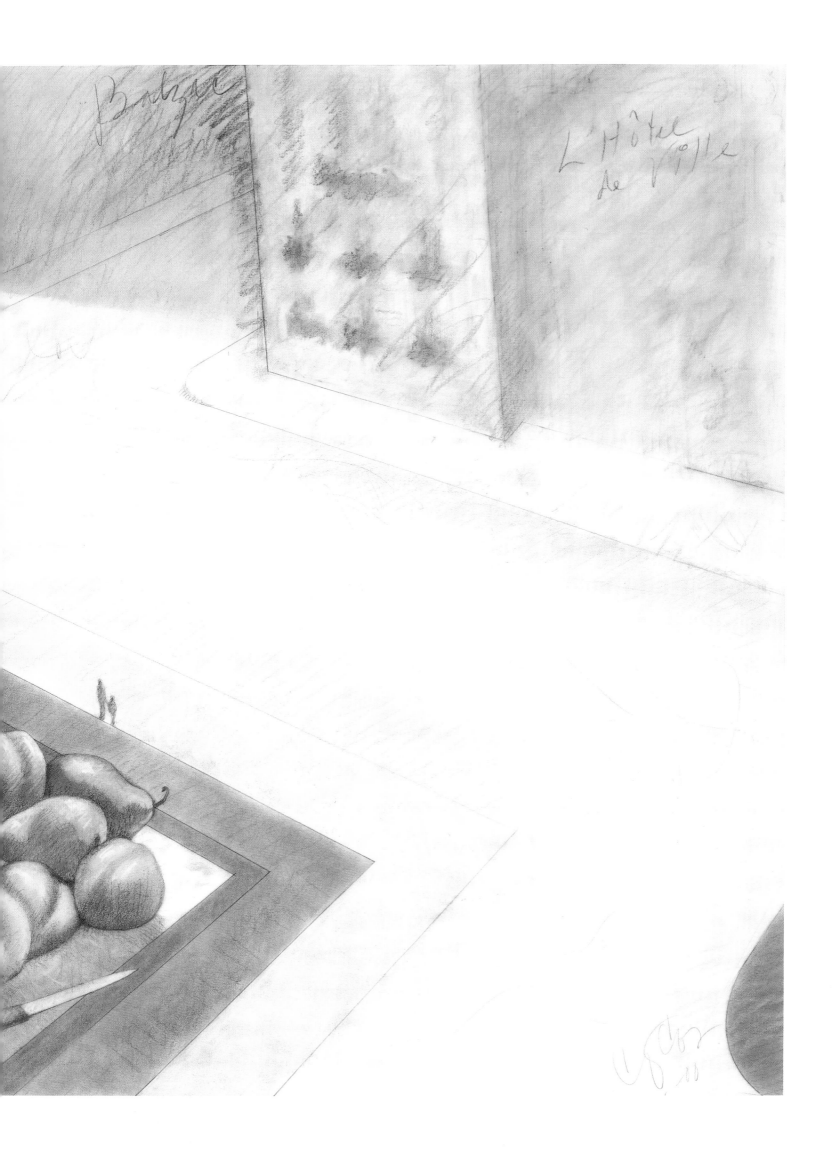

Cover
Study for Book Cover: Composition of Peaches and Pears, 2001
Pastel, charcoal, pencil, tape, collage
Two panels, each 37 3/8 x 24 1/8"; overall 37 3/8 x 48 1/4"

Page 2
detail from *Resonances, after J. V.*, 2000

Photography
J.G. Berizzi; courtesy Réunion des Musées Nationaux / Art Resource, NY: p. 12 (fig. 13)
© 2002 Ben Blackwell: pp. 26–27
Peter Cox: p. 16
David Heald: p. 5 (fig. 4)
William Kreysler and Associates: pp. 34, 35 (images 2, 3, 5)
Attilio Maranzano: pp. 8, 9, 15
Kerry Ryan McFate: pp. 24
© The National Gallery, London: pp. 3, 4
© Nationalmuseum Stockholm: p. 13 (fig. 15)
R.G. Ojeda; © 2002 Estate of Pablo Picasso / Artists Rights Society (ARS), New York;
courtesy Réunion des Musées Nationaux / Art Resource, NY: p. 13 (fig. 16)
Claes Oldenburg: pp. 28, 35 (images 1, 4, 6–9)
Courtesy Réunion des Musées Nationaux / Art Resource, NY: p. 12 (fig. 14)
© Rijksmuseum Amsterdam: p. 5 (fig. 5)
See Spot Run, Inc.: p. 29
Frank Thomas: p. 14
Gian Berto Vanni; Courtesy VANNI / Art Resource, NY: p. 10 (fig. 11)
Ellen Page Wilson: pp. 2, 6, 10 (fig. 10), 19–21, 23, 30–33, 36–39

Design
Tomo Makiura

Production
Paul Pollard
Tucker Capparell

Printed in the United States

ISBN 1-930743-16-5